Robert Rauschenberg

Sam Hunter

Robert Rauschenberg

RIZZOLI
NEW YORK

For Harry Hunter, age 7

First published in the United States of America in 1999 by

RIZZOLI INTERNATIONAL PUBLICATIONS, INC.
300 Park Avenue South, New York, NY 10010

© *1999 Ediciones Polígrafa, S.A.*
Reproduction rights:
© Untitled Press, Inc., VEGAP, Barcelona, 1999
Text copyright © Sam Hunter

ISBN 0–8478–2183–8
LC 99–70292

Designed by Jordi Herrero
Color separations by Format Digital (Barcelona)
Printed by Filabo, S.A.
Sant Joan Despí (Barcelona)
Dep. Leg. B. 26.703-1999 (Printed in Spain)

Contents

ROBERT RAUSCHENBERG: ART AND LIFE

"With Rauschenberg to work is something heroic.
There is always a conquest, a subduing of something
unexpected. Always some new discovery."

Tatyana Grosman[1]

More than anything else, it has been Rauschenberg's curiosity about
the world around him, his freewheeling generosity of spirit and willingness
to reach out, to touch and share his unique way of perceiving his
surroundings on multiple levels that shaped him as one of the most
influential and accomplished artists of his age. Despite his legendary route
to fame and early iconoclasm, he views himself essentially, but proudly, as
a journalist-artist in tune with a groundswell of public events and the
temper of the times who can readily communicate his unique reactions to
a wide audience. He has been quite explicit about this self-image and his
artistic perspective: "I used to say this a good deal, and I try not to say it that
much anymore: I think of my activity more in relation to reporting than I
do as something for an isolated elite."

For nearly five decades Rauschenberg has freely but obsessively
followed this path, producing art works that range from the most prescient,
pre-happening performances to the revival of the time-honored multiple
technique of lithography. The ultimate modernist, he has done far more
than push the boundaries of art. As he struggled to erase an ever more
ephemeral line between them, he tested the famous "gap" between art and
life that he himself first defined so tersely but eloquently, reflecting his
world today.

"Bob has always been able to see beyond what others have decided
should be the limits of art," remarked a member of the older generation of
American abstract expressionists, Jack Tworkov, in the late sixties.
"Twentieth-century art has been a constant expansion of these limits. Of
course people once thought that Cezanne had gone as far as you could go.
But Bob always wants to go still further. Look at what he did with collage. If
it was all right to make pictures with bits of pasted paper or metal or wood,
he asked, then why couldn't you use a bed, or even a goat with a tire? He
keeps asking the question and it's a terrific question philosophically,
whether or not the results are great art, and his asking it has influenced a
whole generation of artists."[2]

Tworkov was the only avant-garde artist of the older, heroic generation to recognize Rauschenberg's early and unwittingly gadfly pose as the *enfant terrible* of the art world. Since Tworkov first observed the younger artist's intuitive grasp of the Zeitgeist in the early fifties, the world has changed dramatically. With the current passion for novelty and the accomodation to rapidly changing styles in art, it has absorbed all too readily the esthetic advances, and visual conundrums which Rauschenberg pioneered in such outrageous inventions as his tire-encircled goat in *Monogram*, for instance, or the dispassionate, nostalgic Spreads that are now taken as a matter of course. They may even seem inevitable in light of the current climate of permissiveness.

Indeed, one challenge in an overview of Rauschenberg's place in history is simply that he has become so integral to later developments in art, a voice echoing his time for nearly half a century, that it is difficult today to experience the original impact of his work as it broke new ground. Rauschenberg's inimitable way of perceiving his environment, translated into tangible form and distinctive pictorial expression, for example, is less a technique than a subliminal adjustment to modern life itself, echoing the staccato vernacular pace that was expressed lyrically in quite different minimalist form by Mondrian's legendary *Broadway Boogie Woogie* as early as 1944, but rarely found either expression or a hearing during the long hegemony of abstract expressionism with its emphasis on angst and heroic emotions.

Rauschenberg was undoubtedly the leading figure in the first generation that turned away from these heroic and militant moods. During his brief exposure to the progressive, experimental Black Mountain College faculty and study with the rather severe Bauhaus master Josef Albers in particular, he experienced a far more objective artistic apprenticeship than the "anxiety of influence" surrounding the New York School. It was Josef Albers, in fact, who had announced that "Angst is dead."[3] A new attitude of even-handedness, and indifference to competing political ideologies, became the rule in the emerging American avant-garde. At the same time Rauschenberg, Johns and other young artists in music, dance, and theater as well as the plastic arts chose to embrace the iconoclastic spirit of Marcel Duchamp, to help liberate them from the heavy hand of the older abstract generation, and that decision moved them into a fresher vision more in tune with the postwar world.

"Rauschenberg's esthetic of the unrepeatable glance, the second time you look, the work has changed, is connected to the kind of instantaneous overall perception clarified later by a vastly different kind of art," the *New York Times* art critic Brian O'Doherty wrote in a 1973 analysis. "But once the Rauschenberg work broke down, that is, on the second glance, it lapsed into

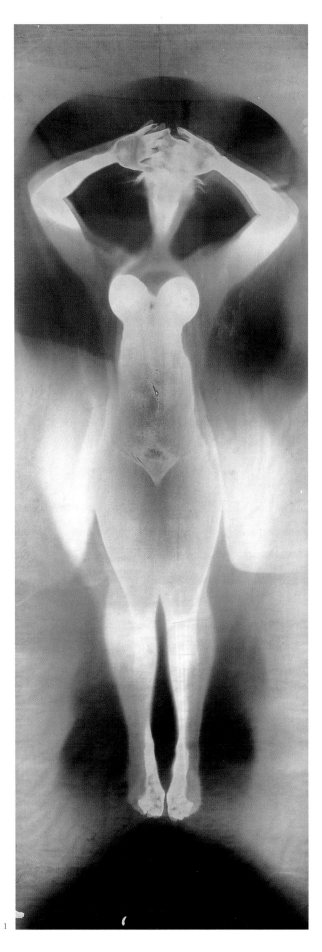

1.
Female Figure (Blueprint),
c. 1949.
Made with Susan Weil.
Monoprint: exposed
blueprint paper, 106×36 in.
(269×91 cm).

a kind of additive dementia. The only time it held together was at first glance. It takes years to put it together again for the museum audience, and of course the past decade has more or less accomplished that.

"Works such as Rauschenberg's thus have a lost mode of perception buried in them, as the esthetic of 'museum perception' instructs academic modes of looking quite alien to the original."[4]

And certainly the keys to understanding works that can now appear "alien," even in an age of extreme cultural diversity, are both the notion of Rauschenberg's "vernacular glance," as his friend and fellow artist O'Doherty explained it, and new to the vast and ever expanding literature on Rauschenberg's art, his crucial dyslexia.[5] It was his dyslexia since early childhood that has been connected by some scholars to his freely improvised and non-sequential compositions, and even his bursts of protean versatility.

By his own accounts, Rauschenberg's role in his works is more medium than creator, with chance and humor functioning to separate him as a distinct personality from his objects, which are neutral and even uninteresting in intention. In a letter written by Rauschenberg to the New York dealer Betty Parsons at the time he was creating his first collaborative work at Black Mountain College, the neophyte artist boldly described his paintings as non-art, "because they take you to a place in painting where art has never been." Then in environmental terms reminiscent of Cage's non-volitional esthetic, he even denied his responsibility for bringing them into being. "Today," he wrote, "is their creator."[6]

Ever a mercurial figure, Rauschenberg eluded public apprehension and definitions by constantly shifting styles and adhering to his own intuitive program of freedom and novelty of means and themes. The critical figures in his life who have discussed his artistic personality and their relations with Rauschenberg agree only on his buoyancy and expansive energies which art journalist Dorothy Seckler captured so effectively in her taped interviews some time ago. Her conversations with the artist offered new insights at a time when he was experiencing a sudden and overwhelming fame, after years in the shadows. She writes that she encountered a tall, slender artist with an " . . . open face, a habit of moving as if his tennis shoes carried an extra charge of bounce and a pleasantly resonant voice which had a trace of a Southern accent. His conversation revealed no nihilistic spleen or dada ironies, despite his *enfant terrible* reputation; far from seeming a rebel of any stripe, he conveyed a sense of continuous delight at the discoveries of every shining hour."[7]

More recently, in an interview in New York in 1989 with the author of this monograph, Rauschenberg remained much the same unfettered free spirit, tempered a bit at the time by occasional negative

2

3

2.
Crucifixion and Reflection,
c. 1950.
Oil, enamel and water-based
paint, and newspaper on
paperboard, attached to
wood support,
47 ³/₄×51 ¹/₈ in.
(121.4×130 cm).

3.
22 The Lily White, c. 1950.
Oil and pencil on canvas,
39 ¹/₂×23 ³/₄ in.
(100.3×60 cm).

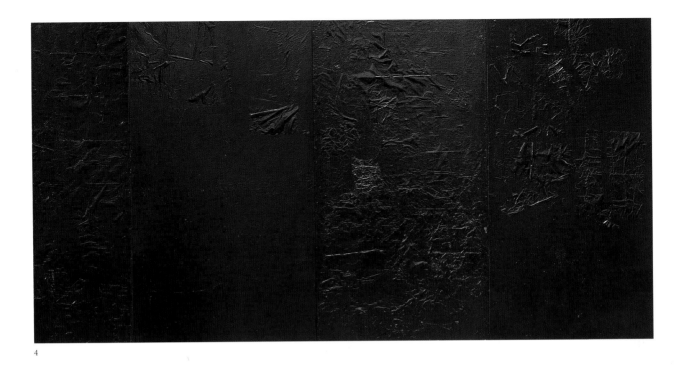

4

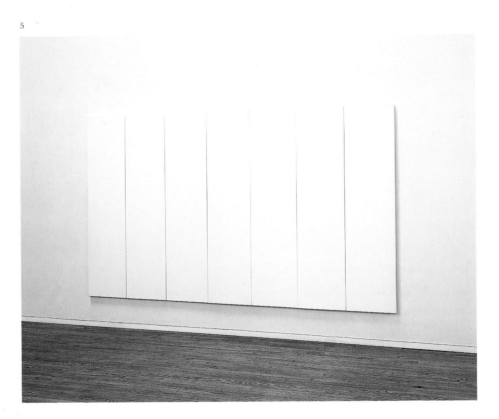

5

4.
Untitled, c. 1951.
Oil and newspaper on four
canvases, 87×171 in.
(221×434 cm) overall.

5.
White Painting, 1951.
Oil on canvas, 72×126 in.
(seven panels)
(182.9×320 cm).

criticism in the press of his putatively uncritical artistic productivity, at least in the minds of a few self-appointed *cognoscenti* who disliked his new work. But this criticism proved to be only a small bump in the generally steady upward trajectory of his flourishing career. His work now emanated not from an oppositional, distracting New York, as he then perceived the American art center, but from an idyllic studio on an island on the west coast of Florida that became his retreat and salvation two decades ago.

His creative output in paintings, prints and objects has been prodigious and astonishing in this period, all the more so since it included his major, itinerant project of the decade, launched in 1985 with such adaptive facility mainly on the road, on trips to China, Tibet, Japan, Chile, the countries of Europe and Asia, and many other countries. There he visited traditional cultural centers and distant provincial outposts, all part of the grandiose, collaborative project known as Rauschenberg Overseas Culture Interchange, or ROCI—an ambitious, multifarious one-man, one-world artistic enterprise and cultural good will tour which was only recently concluded, and has immeasurably expanded from its initial impulses.

As a result of the artistically unprecedented ROCI experience and the constant flow of work from his permanent Florida studio, his palette of colors and materials has apparently grown brighter, more luxurious, and his imagery more fanciful, as if his normally euphoric mood had been raised to new intensities, perhaps also in response to the brilliant Florida light and the total concentration afforded by his protective work environment. The works of the past decade, nonetheless, do convey an impression of what life is like in the fast lane in late-20th-century America, with their distracting sign fragments, imaged highways and byways, the collisions and refractions playing to a frenetic society's accustomed condition of an accelerating information overload. For Rauschenberg the medium with its variable accents, and his multiplying series of Gluts, Shiners, Urban Bourbons and other euphonious and prolific titles have reopened powerful new expressive alternatives in his art of the nineties.

Yet a distinct and definable consistency remains in the artist's outlook no matter how various or opportunistic his inventions. The synoptic, flashing juxtapositions of silk-screened imagery nostalgically recall the visual strategems of the sixties; the collage techniques and unexpected material contrasts here and there, deliberately untidy contours and lavish paint smears yards long in these new and improved "combines" remind us that his works continue to bridge the gap between action painting and pop art as well as the seminal gap between art and life which he has so compellingly staked out for himself.

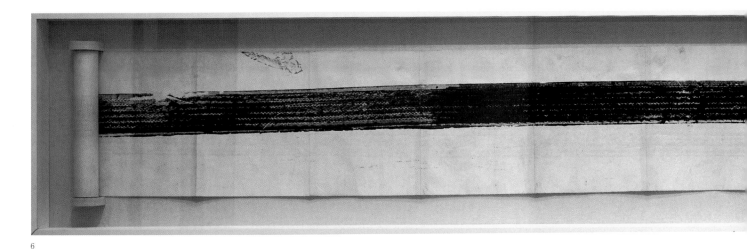

6

7

6.
Automobile Tire Print, 1951.
House paint on twenty
sheets of paper, mounted on
fabric, 16¹/₂×264¹/₂ in.
(fully extended) (42×671 cm).

7.
Dirt Painting (for John Cage),
c. 1953.
Dirt and mold in wood
frame, 15¹/₂×16×2¹/₂ in.
(39.4×40.6×6.4 cm).

8.
Untitled (Gold Painting),
c. 1953.
Gold and silver leaf on fabric,
newspaper, paint, wood,
paper, glue, and nails on
wood, in wood-and-glass
frame, 10¹/₂×11¹/₂×1³/₈ in.
(26.7×29.3×3.6 cm).

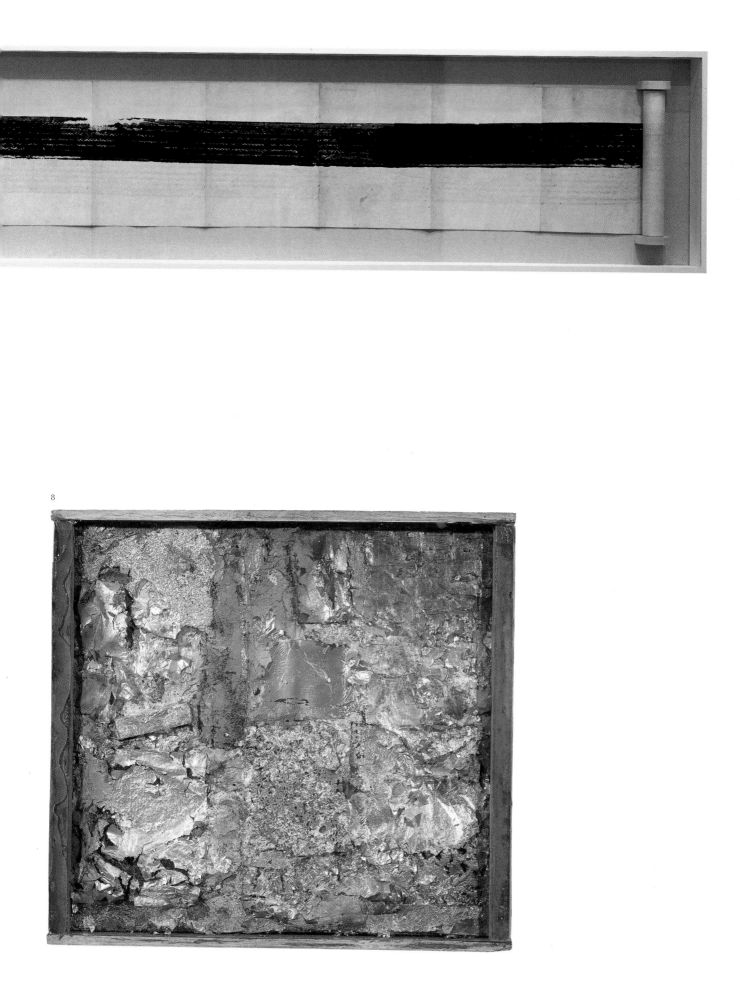

8

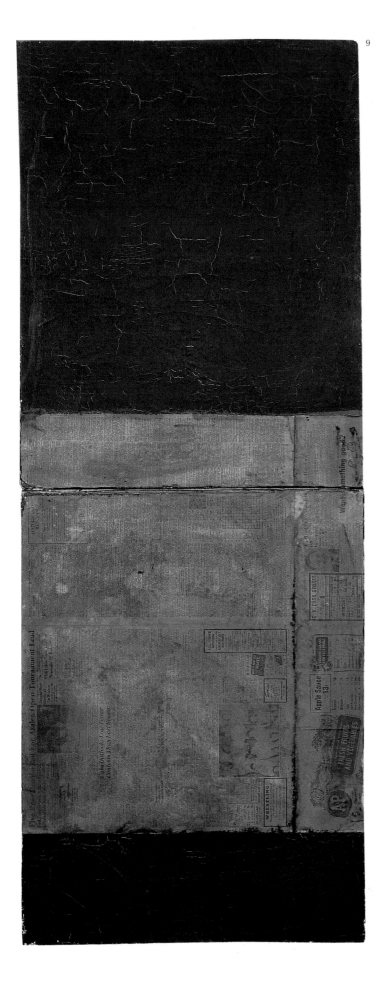

9

10

9.
Untitled, c. 1952.
Oil and newspaper on two
canvases, 72¹⁄₄×28¹⁄₂ in.
(182.9×72.4 cm).

10.
Untitled, c. 1952.
Engraving, pencil, and glue
on paper mounted on paper-
board, 10×7 in. (closed)
(25.4×17.7 cm).

11.
Untitled (Elemental Sculpture),
c. 1953.
Assemblage: bricks, mortar,
steel spike, metal rod, and
concrete, 14×8×7³⁄₄ in.
(36.3×20.3×19.8 cm).

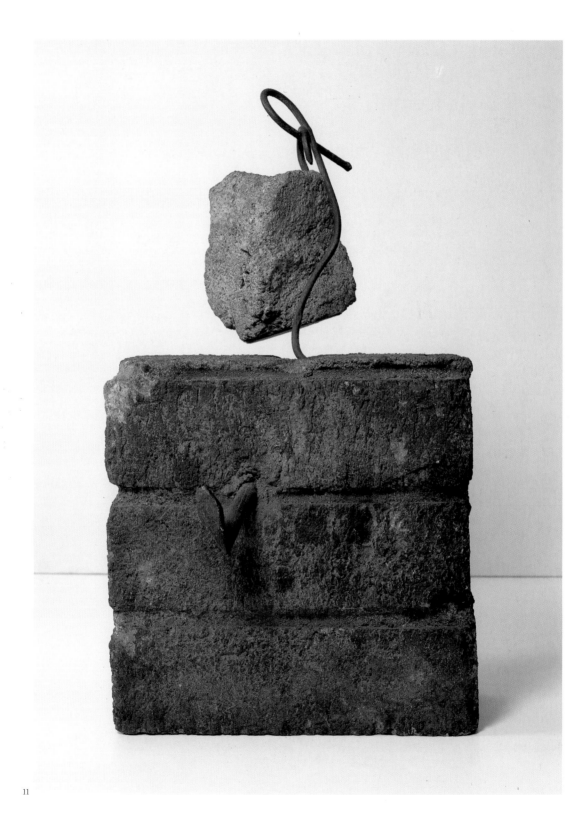

11

12

Now, as in the beginning, the working process itself primarily counts for him. "Work is my joy," Rauschenberg recently explained to a biographer in his airy studio on the island of Captiva. Located on the Gulf Coast of Florida, far from the tourist routes, Captiva offers an oasis of freedom and special magic for him where he can now explore new visions and techniques, expanding on themes so all-encompassing that his work seems continually fresh. "Work is my therapy. I don't know anybody who loves work as much as I do," he says.[8]

In his Captiva compound, with the isolated "Fish House" on stilts in the Gulf of Mexico and his two-story studio, Rauschenberg and a handful of assistants spend long nights assembling works that vary from intimate to monumental scale, and grow ever more inclusive in their wide variety of found and/or reconstructed objects. His Gluts, Shiners and most recent Borealis series, like the works and materials he initiated and assembled in countries from China to Chile on his recently concluded ROCI tour, come into being in this friendly space in extended bursts of enormous energy, mostly in the small hours of the morning. Rauschenberg and his assistants work here from a literally superabundant "glut" of materials, precisely organized so that they are easily accessible in stacks of screened, printed and tabulated images, and tidy rows of pigments neatly labeled.

Studio work usually follows a morning of sleeping in and an afternoon round of routine activities. Dinner in the Captiva compound may be a menu prepared by Chef Rauschenberg for his staff and working crew; it leads to what he most enjoys: his intuitive, ongoing work as the hours of the tropical nights unwind. For him, Captiva has been more than a winter escape. He retreated to the small island in the late 1960s, to escape a New York art world that was lionizing him to the point of intolerable distraction.

From the beginning, Captiva has more than lived up to the mystic paradise promised him by an astrologer. "Every time I came to Captiva something magic happened," he recalled. "Like having to stop the car because of a big turtle crossing the road, or stepping out of the car and having forty yellow butterflies all of a sudden come at you . . . I had the ghost of having been here before. There was something familiar about it."[9]

It is hardly surprising that Rauschenberg would feel a sense of comfort and security on his personal island, a sense that he was coming to a benevolent environment where he could work without distraction. After a life at the heart of vanguard art, he longed for sanctuary and uninterrupted work time. In a turbulent and competitive New York and at freewheeling Black Mountain College, where Joseph Albers was openly disdainful of Rauschenberg's nascent efforts, the young artist absorbed his first valuable lessons in life and art. He had then experienced Paris briefly and hectically as a neophyte, fifteen years too late, he has said ruefully. His

12.
Yoicks, 1954.
Oil, fabric and newspaper on two canvases, 96×72 in. (244×183 cm).

later trips to Europe, which commenced soon after leaving Black Mountain College in 1952, were eye-opening journeys, first allowing him a welcome obscurity, but later exposing him to a disorienting and glaring limelight in Venice in 1964 when he made off with a controversial Grand Prize in painting. It was soon after that media circus that he found his Florida Eden and began to spend part of each year working there, although he also maintained a spacious New York studio building. Rarely used as a work-space, it serves mainly as the repository for some of his work, operated by a devoted and efficient staff that maintains an invaluable archive and other records of his work and farflung activities.

If Captiva finally became his calming workplace and a spiritual haven, it stands in dramatic contrast to Port Arthur, an unpleasant, sweltering coastal Texas town where he was born, on October 22, 1925, and spent his entire childhood. He lived there in his youth without benefit of anything that would point to a future life in art. From Port Arthur, eleven miles away from the Gulf of Mexico (and also the birthplace of a fellow free spirit, musician Janis Joplin, a major figure in his galvanizing 1970 print, *Signs*) there were no family outings to concerts, and certainly no prospects of jaunts to American or European capitals.

There were also no art classes and no museums. Other than the religious kitsch that hung on the walls of his home, there was nothing resembling art, and no sense that art could form the basis of a career, much less an entire life, Rauschenberg recalled. His mother was clear about the reasons, and her statement might suggest the impetus for a rebellious spirit to escape and seek change and liberation elsewhere: "We were ordinary working people," Dora Matson Rauschenberg explained. "Art was not in our world."[10]

In their world, however, there was respect for craft and domestic industry. Dora Rauschenberg, a beauty from Galveston who had been a telephone operator in Port Arthur before marrying his father, was known for her skills as a seamstress. During the Great Depression, when the entire nation shared the need to scrimp, she was admired for her ability to arrange paper patterns so tightly on cloth that not a scrap was wasted; it seems that her economy and ingenuity were not lost on her gifted son who would later move on to another cultural environment.

"That's where I learned collage," Rauschenberg has said. His respect for texture, pattern, design and, more pointedly, for the randomness inherent in a process of arranging and rearranging elements to fit later became an identifiable feature of his own different productions. Two fundamental aspects of his own approach may be traced, with some stretch of the imagination, to the time he spent watching his mother piece together pattern and fabric: collaboration and a fine, constantly shifting balance between

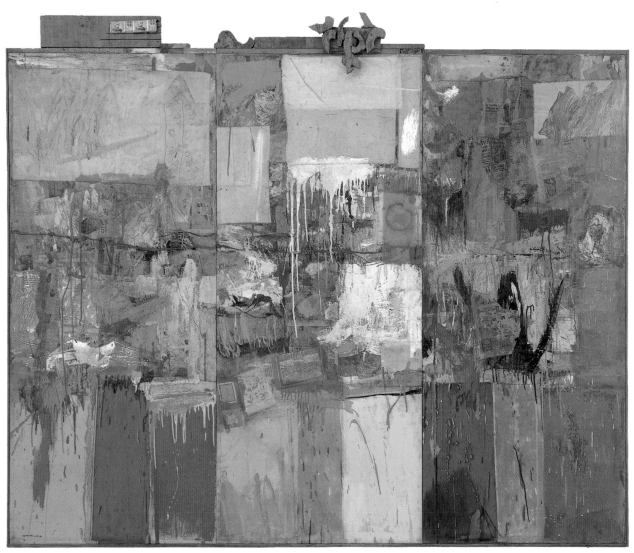

13

13.
Collection, 1953–54.
Combine painting: oil, paper,
fabric, newspaper, printed
reproductions, wood, metal,
and mirror on three wood
panels, 79×95 3/8×3 1/4 in.
(203.2×243.8×8.9 cm).

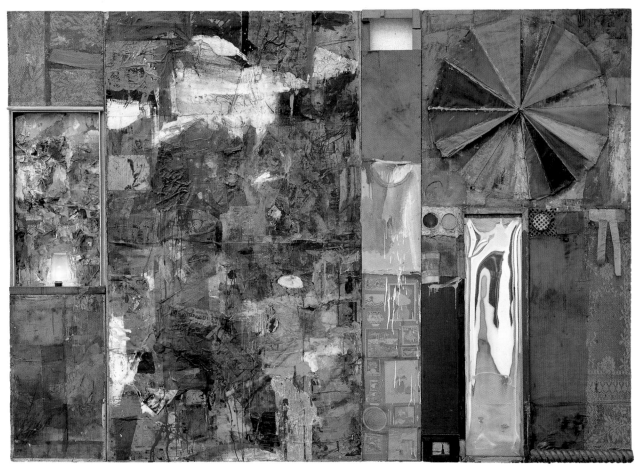

14

14.
Charlene, 1954.
Combine painting: oil,
charcoal, paper, fabric,
newspaper, wood, plastic,
mirror, and metal on four
Homosote panels, mounted
on wood, with electric light,
89×112×3¹/₂ in.
(226×284×8.9 cm).

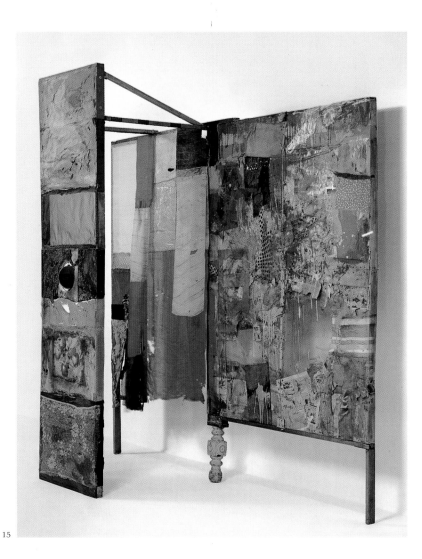

15

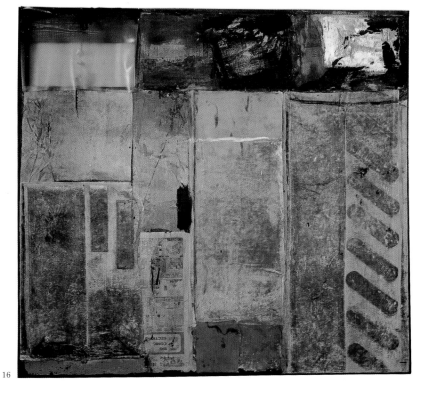

16

15.
Minutiae, 1954.
Combine: oil, paper, fabric,
newspaper, wood, metal,
plastic, with mirror on
string, on wood structure,
84³/₄×81×30¹/₂ in.
(215×206×77 cm).

16.
Red Interior, 1954–55.
Combine painting: oil, fabric,
and newspaper on canvas,
with plastic, wood, metal-and-
porcelain pulley, pebbles, and
string, 55⁵/₈×61×2⁵/₈ in.
(141.3×154.9×6.7 cm).

17.
Rebus, 1955.
Combine painting: oil,
paper, fabric, pencil, crayon,
newspaper, and printed
reproductions on three
canvases, 96×130½ in.
(243.8×331.5 cm).

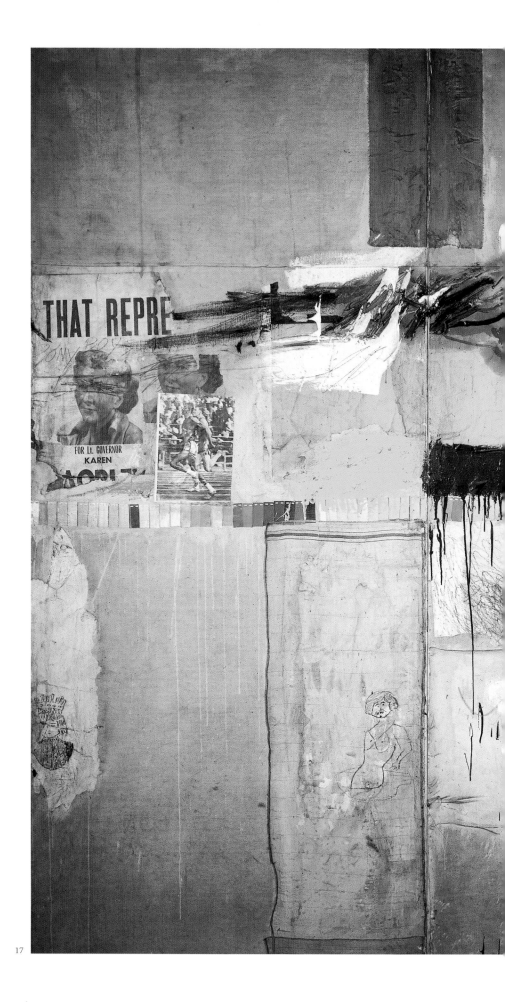

17

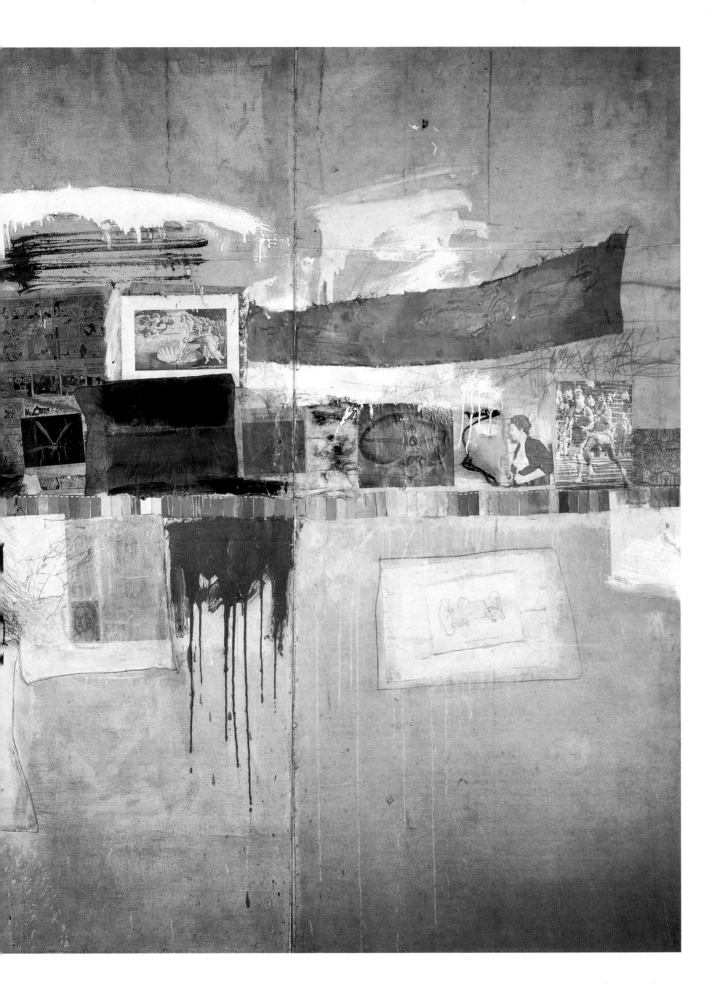

opposites of all sorts, even emotions. As a boy, he was embarrassed to wear his mother's homemade, patchwork shirts, and he later was frank about that. But he also is frank about the pride he felt in his mother, who made the time to sew for him.

Mrs. Rauschenberg's reason for sewing the cotton shirts that caused some chagrin, and may be linked distantly to her son's massive combine-paintings and to the many fiber-based spinoffs that are so closely related, adds another dimension to the history of Rauschenberg's collages. His mother explained that she wanted him to have new clothes, because as a girl she had had to wear too many hand-me-downs; through her work, she felt she was able to spare her son the sort of shame she had felt.[11]

As a boy he was somewhat shy, quite serious, and appropriately religious in a family centered around the fundamentalist Church of Christ—until he was a teenager, Rauschenberg planned to become a minister. His father, a power-company lineman and somber disciplinarian, was the child of unlikely parents: Robert Rauschenberg was a doctor who emigrated to Texas from Berlin in the nineteenth century, and married a Cherokee woman. The artist never met his grandmother, but always remembered and publicly recalled links to his Native American roots. He also still speaks of his favorite activities in a generally carefree childhood: fishing in the Gulf of Mexico, raising a veritable farmyard of dogs, ducks, rabbits, frogs, and a goat, and doodling. He copied cartoons in the margins of his notebooks and in one notable incident, which won him a threat of a whipping, painted fleur-de-lis on his bedroom walls. A shy child, he often hid from people, finding solitude by climbing trees or crawling under his house to play with his insect collection. But he was clearly high-spirited, too, riding on his bicycle, whittling, go-carting, even impishly swimming across the church pool after his baptismal immersion ceremony.[12]

Some friends and teachers remember him as a good-looking, pleasant youth, if somewhat diffident. He was, one drama-club colleague said, "a handsome boy, with a clear, fair complexion . . . not full of himself . . . [but] humble within himself, and kind to everyone." But that was just one side of Rauschenberg, said teacher Mary Evelyn Dunn Hayes. She recalled more dynamic traits: "a DEFINITE leader . . . an above-average student, gregarious, an extrovert, but with such good manners. Whenever he saw you, anywhere, he 'helloed' you just like he was so glad to see you . . . he always had ideas: Milton always had some solution to suggest."[13]

It was that sensitive balance between opposites, a sort of intuitive tension or innate yin/yang that would persist in his character, and emerge in fascinating forms and ever-shifting guises in his art. He was glad to leave behind Port Arthur and its oppressive small-town conformity in the fall of 1942, enrolling at the University of Texas in a pre-pharmacy program during those war years. But there, as in high school (where, he later would

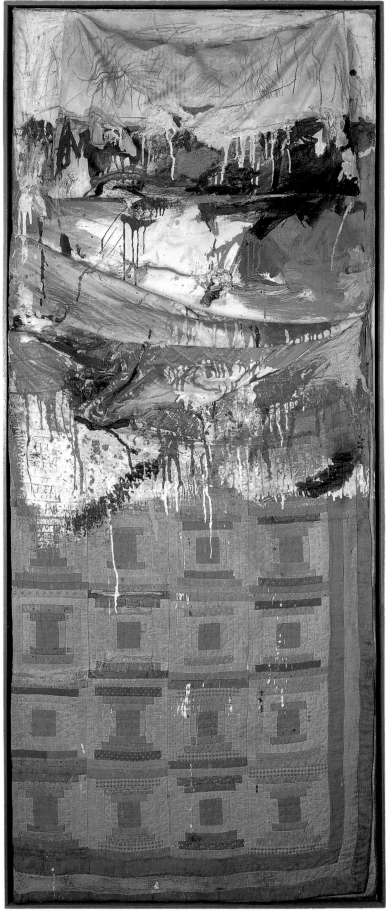

18.
Bed, 1955.
Combine painting: oil and
pencil on pillow, quilt, and
sheet, mounted on wood,
75$\frac{1}{4}$×31$\frac{1}{2}$×6$\frac{1}{2}$ in.
(191.1×80×16.5 cm).

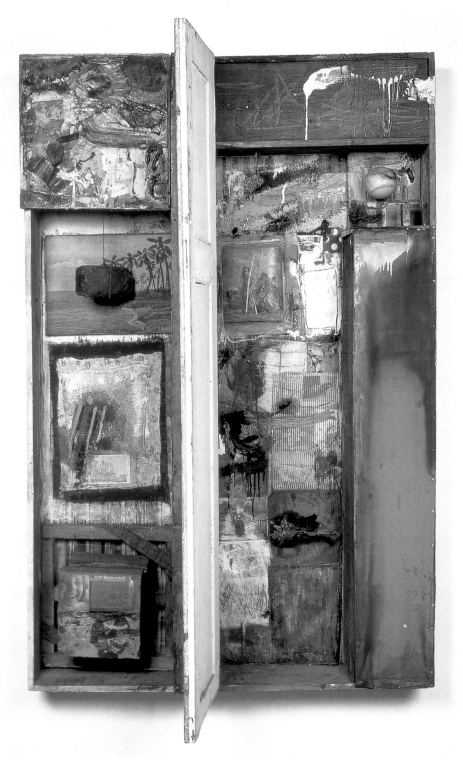

19.
Interview, 1955.
Combine: oil, pencil, paper, fabric, photographs, printed reproductions, newspaper, wood, baseball, metal fork, found paintings, hinged wood door, and brick on string, on wood structure, 72¾×49¼×12 in. (184.8×125.1×30.5 cm).

20.
Untitled, c. 1954.
Combine: oil, pencil, crayon, paper, canvas, fabric, newspaper, photographs, wood, glass, mirror, tin, cork, and found painting, with pair of painted leather shoes, dried grass, and Plymouth Rock hen, on wood structure mounted on five casters, 86½×37×26¼ in. (218.4×96.5×67.3 cm).

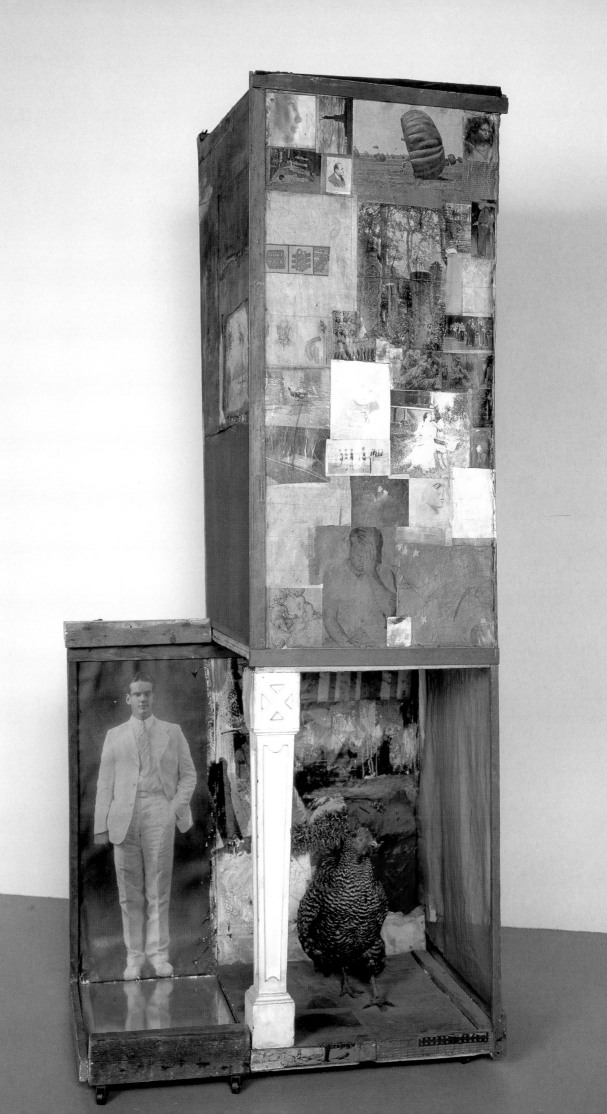

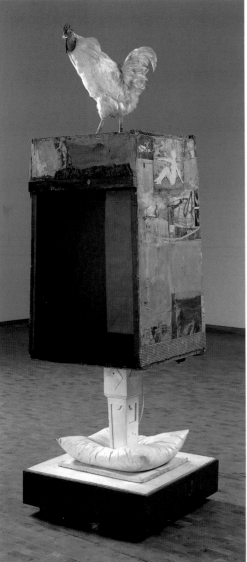

21.

21.
Odalisk, 1955–58.
Combine: oil, watercolor,
pencil, crayon, paper, fabric,
photographs, printed
reproductions, miniature
blueprint, newspaper, metal,
glass, dried grass, and steel
wool, with pillow, wood post,
electric lights, and Leghorn
rooster, on wood structure
mounted on four casters,
83×25¼×25⅛ in.
(210.8×64.1×63.8 cm).

22.
Hymnal, 1955.
Combine painting: oil, paper,
fabric, printed paper, printed
reproductions, and wood on
fabric, with telephone
directory, metal, and string,
64×49¼×7¼ in.
(162.6×125.1×18.4 cm).

23.
Memorandum of Bids, 1956.
Combine painting: oil,
pencil, paper, printed paper,
and fabric on canvas,
59×44½ in. (149.9×113 cm).

22

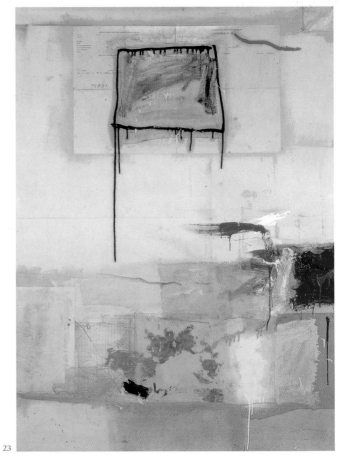

23

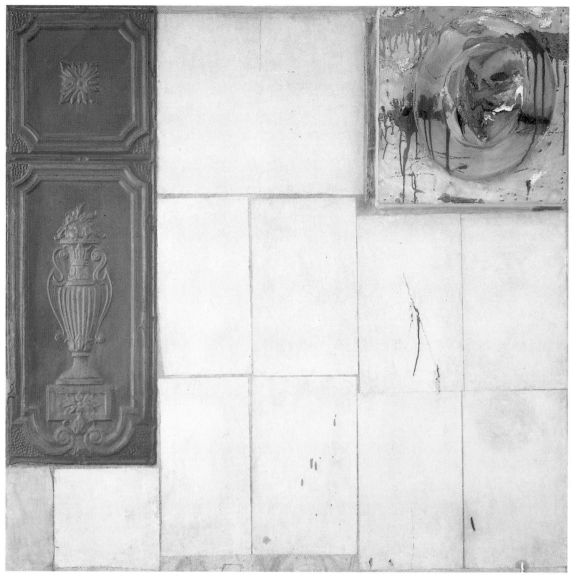

24

24.
Interior, 1956.
Combine painting: oil, house
paint, paper, fabric,
embossed metal, wood, nails,
and leather hat on canvas,
45$\frac{1}{4}$×46$\frac{1}{2}$×7$\frac{1}{2}$ in.
(114.9×118.1×19.1 cm).

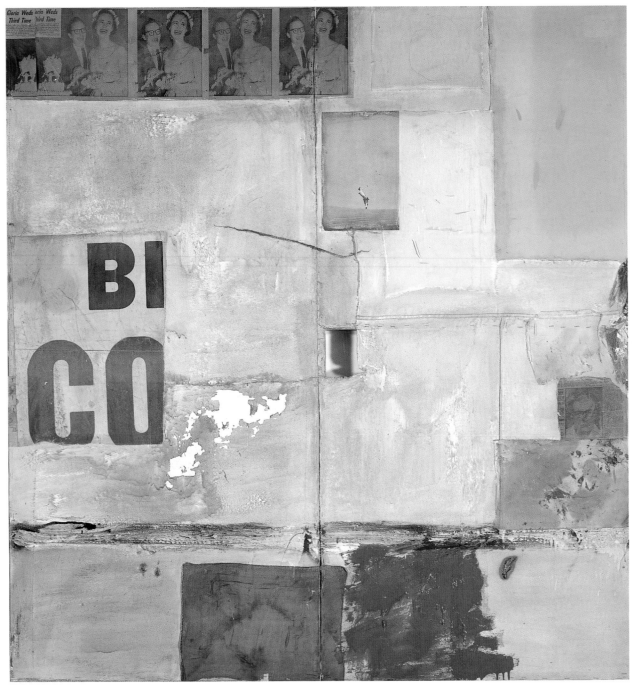

25

25.
Gloria, 1956.
Oil and paper collage on
canvas, 66 $^{1}/_{4}$×63 $^{1}/_{4}$ in.
(168.3×160.7 cm).

chuckle, he excelled in poor grades), study was an uphill struggle for eager, diffident Rauschenberg. He refused to dissect a frog, a pre-requisite for his program; more serious, however, were the visual difficulties that since childhood had made reading a torment.

No one knew then that he had dyslexia, the learning disability. Perhaps, in retrospect, it can now be regarded as simply an alternate way of seeing, one that he would later intuitively harness and use to transform art by putting onto paper or canvas the world as he felt and saw it. Rauschenberg has explained his creative process as essentially something beyond conscious control, though he said he has "various tricks to actually reach that solitary point of creativity. One of them is pretending I have an idea. But that trick doesn't survive very long because I don't really trust ideas—especially good ones.

"Rather, I put my trust in the materials that confront me, because they put me in touch with the unknown. It is then that I begin to work . . . when I don't have the comfort of sureness and certainty. Sometimes Jack Daniels helps too. Another good trick is fatigue. I like to start working when it's almost too late . . . when nothing else helps . . . when my sense of efficiency is exhausted.

"It's then that I find myself in another state, quite outside myself, and when that happens there's such a joy! It's an incredible high and things just start flowing and you have no idea of the source."[14]

Thus Rauschenberg depends for his creative wellsprings not on a rational, predictable process but on an intuitive translation of perception and vision into two or three—most often three—dimensions. To divert his consciousness from the energies that seem to mysteriously, even mediumistically, produce works of art, he may think of peripheral matters, engender an altered state by disinhibiting himself with whiskey or fatigue, or disengage his concentration by working on several pieces at the same time. Whether they are tricks or rituals, Rauschenberg's methods invariably allow him to tap into what he considers the ongoing flow of life, the ever-varied vistas that surround him.

His artistic stance and methods were not simply a matter of reacting against the dominant esthetic of abstract expressionism of his period when he layered canvases with newsprint and then overpainted them thickly with randomly acquired pigments, or when he assembled massive collages that projected aggressively into the viewer's space. He was working with what he had, with found objects and a skewed environment, but he also was working with perceptions that were naturally altered. As a child, he had experienced difficulty in school without realizing how different his world appeared. By the time he was an adult, he had a clear, if intuitive grasp of those differences, as he became aware of his dyslexia, and what it meant to him and his artwork.

"I already see things backwards! You see, in printmaking everything comes out backwards so printing is an absolute natural for me. It is difficult for a lot of artists to do prints because they draw one way and can't imagine it the other way. I always had trouble reading as a child. Every few minutes my mind would shift and I would pick out all the o's, then all the letter a's on a page," he has recalled.

"I still have a struggle reading and so I don't read much. . . . Probably the only reason I'm a painter is because I couldn't read, yet I love to write, but when I write I know what I'm writing; when I'm reading I can't see it because it goes from all sides of the page at once. But that's very good for printmaking."[15]

As it has been for him in the field of vision, he has exploited and engaged his dyslexia metaphorically and compositionally in his invention of combine paintings. A common feature of dyslexia is image reversal and rotation, both significant aspects of Rauschenberg's paintings. From an early work like *22 The Lily White* of about 1950 to passages in the immense *Barge* of 1962–63 and the exuberant, ongoing *1/4 Mile or 2 Furlong Piece* of 1981 to the present day, a characteristic aspect of his prodigious output has been images rotated sideways or shown upside-down. The viewer's first impression might be one of agitated horror vacuui, with the artist seeming to cram random jottings and references into every available square inch as his mother once laid out her paper patterns to avoid waste.

But much more is at stake in Rauschenberg's work than an homage to thrift, or a desire to decorate obsessively. Whether he's adding images by hand, transferring them with solvent and pen-nib or using silkscreens, novelty is a key objective. "There's the same quality of surprise and freshness that I have when using objects," he has said. "When I get the [silk]screens back from the manufacturer, the images on them look different from the way they did in the original photographs, because of the change in scale, so that's one surprise right there.

"Then, they look different again when I transfer them to the canvas, so there's another surprise. And they keep suggesting different things when they're juxtaposed with other images on canvas, so there's the same kind of interaction that goes on in the combines, and the possibilities of collaboration and discovery."[16]

For a dyslexic, merely reorienting an image creates a sense of novelty, of seeing something not seen before. Add changes in color, texture, scale, size and combinations with other images, and the effect for an artist like Rauschenberg is one of continual joyous change. To avoid a literal sense of glut, of an undifferentiated and disorganized collection of images, he has since the earliest works used a simple rectilinear device in his paintings. A loose, warped grid presents the numbers in *22 The Lily White* as part of a childlike hopscotch game, or perhaps graffiti. More rigid, and tightly

26.
Factum I, 1957.
Combine painting: oil, ink, pencil, crayon, paper, fabric, newspaper, printed reproductions, and printed paper on canvas, 62×35½ in. (157.5×90.2 cm).

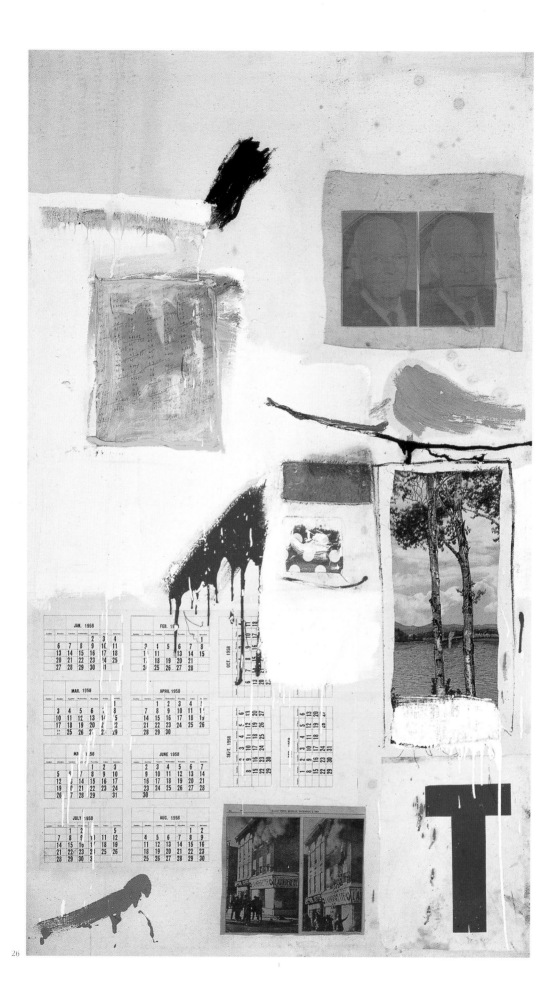

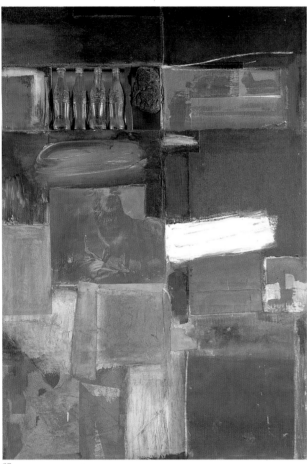

27

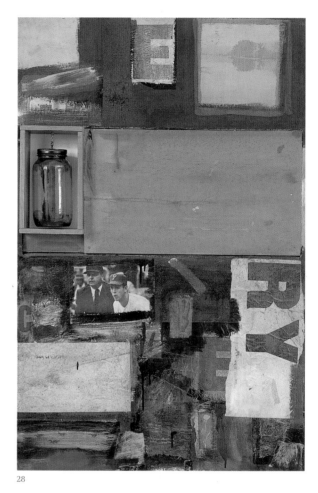

28

27.
Curfew, 1958.
Combine painting: oil, paper,
fabric, wood, engraving,
printed reproductions, and
printed paper on canvas and
wood, with four Coca-Cola
bottles, bottle cap, and
unidentified debris,
56¹/₂×39¹/₂×2⁵/₈ in.
(143.5×100.3×6.7 cm).

28.
Talisman, 1958.
Combine painting: oil, paper,
wood, glass, and metal,
42¹/₈×28 in. (107×71.1 cm).

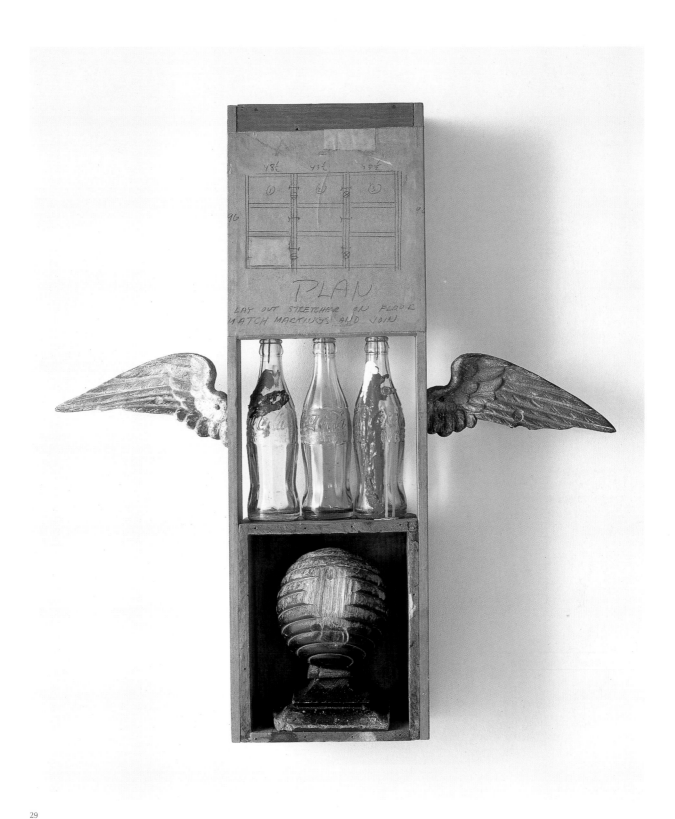

29

29.
Coca-Cola Plan, 1958.
Combine painting: pencil on
paper, oil on three Coca-Cola
bottles, wood newel cap, and
cast-metal wings on wood
structure, 26³/₄×25¹/₄×4³/₄ in.
(68×64.1×12.1 cm).

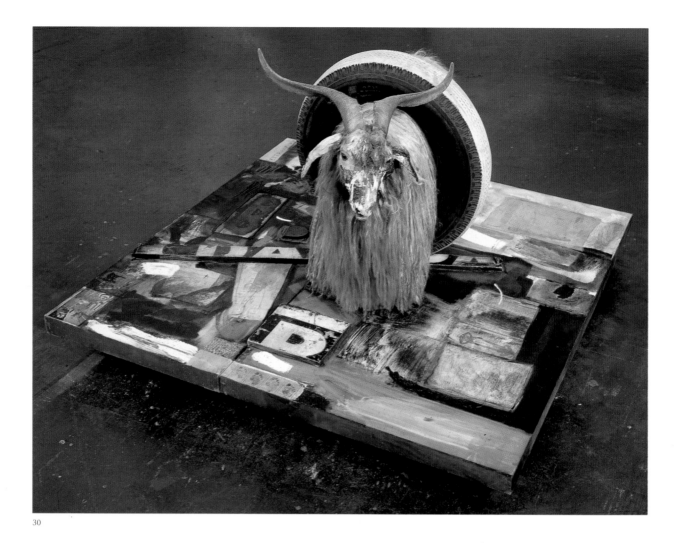

30.

30.
Monogram, 1955–59.
Combine painting: oil, paper,
fabric, printed paper, printed
reproductions, metal, wood,
rubber shoe heel, and tennis
ball on canvas, with oil on
Angora goat and rubber tire, on
wood platform mounted on
four casters, 42×63¼×64½ in.
(106.7×160.7×164 cm).

31.
Gift for Apollo, 1959.
Combine painting,
43¾×29½ in. (111.1×74.9 cm).

31

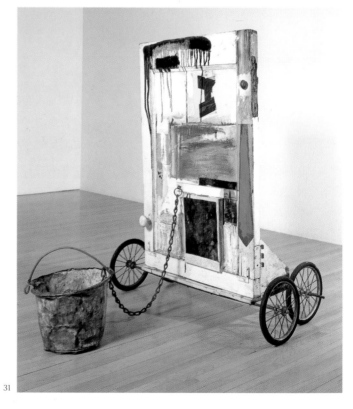

controlled, are the alignment of horizontal and vertical axes in *Crucifixion and Reflection*, also from 1950, and the overt grids in works as varied as the White and Black Paintings of the 1950s, cool modular statements, and *Bed* of 1955, which retains the actual readymade patchwork blocks of its quilt.

By organizing space, experienced in fragments that make what is known as "selective attention" difficult, Rauschenberg tethers his images and makes sure that they will not overwhelm with equal importance or allover intricacy. Indeed, such alignment of vertical and horizontal is a technique taught to dyslexics to help them arrange information in a usable pattern. Also of interest in this context is the allover quality of Rauschenberg's work, one that in terms of color the artist has dubbed "pedestrian" because, as in crowds of people rushing past on a city street, individual spots of bright hue are indistinguishable in the aggregate effect. People with ordinary vision easily differentiate among figures in crowds, separating them from their backgrounds; to a dyslexic, however, such distinctions are difficult to make.

The dyslexic sees the world as a whole, the world indeed appears as an undifferentiated whole. Figures and background fuse, with forms embedded in their surroundings rather than standing out. The equal emphasis given to the world's distinct elements by dyslexics is not very different from the emphasis in Rauschenberg's works. In fact, O'Doherty's notion of the vernacular glance also fits his paintings' structure, or lack thereof. The vision projected is much what a dyslexic apprehends of the world as he passes through it without taking the time to tease its images apart. Not only does Rauschenberg give us the modern vernacular glance in his work; he also gives his viewers a glimpse into his own private and metaphoric universe, literally revealing his own peculiar angle of vision, as it has, in fact, always existed for him.

But at the heart of Rauschenberg's world of art is, simply, Rauschenberg himself. His early curiosity, his bright inquiring mind and willingness to extend himself in ways that might seem out of place in many shy or retiring personalities, grew as he did. He found a variety of performances and everything connected with them irresistible. Though he had trouble memorizing his lines, he was in every high-school theatrical production; some of the appeal of the theater from the start was surely that it allowed him to slip out of his own narrow experience and tap into his imagination. Indeed, so much of his work involves a reflection of internalized reactions—varied, flickering in and out of consciousness, fading and overlapping as real images do in memory—that the diaristic aspects of his oeuvre cannot be overlooked.

His fragmentary and skewed images, dreamlike though they may appear because of their blurred edges, overlaps, repetitions and distorted

32

32.
Wager, 1957–59.
Combine painting: oil,
pencil, paper, fabric,
newspaper, printed
reproductions, photographs,
wood and pencil body
tracing on four canvases,
81×148×2¼ in.
(205.7×375.9×5.7 cm).

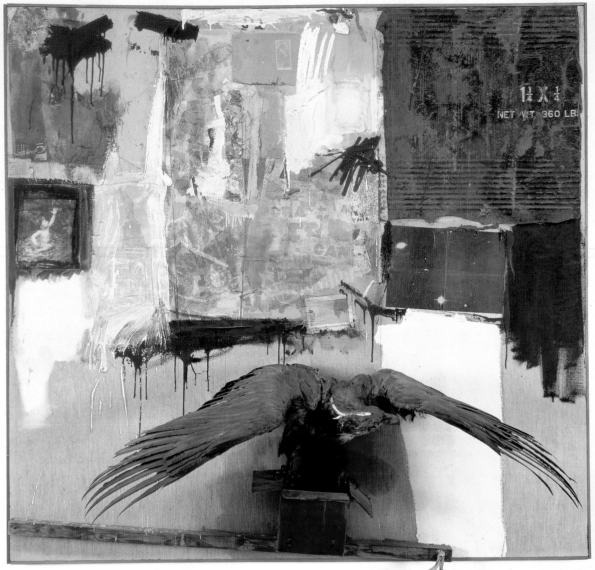

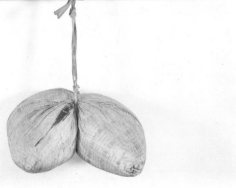

33.
Canyon, 1959.
Combine painting: oil, pencil,
paper, fabric, metal, cardboard
box, printed paper, printed
reproductions, photograph,
wood, paint tube, and mirror
on canvas, with oil on bald
eagle, string, and pillow,
81³/₄×70×24 in.
(207.6×179.1×61 cm).

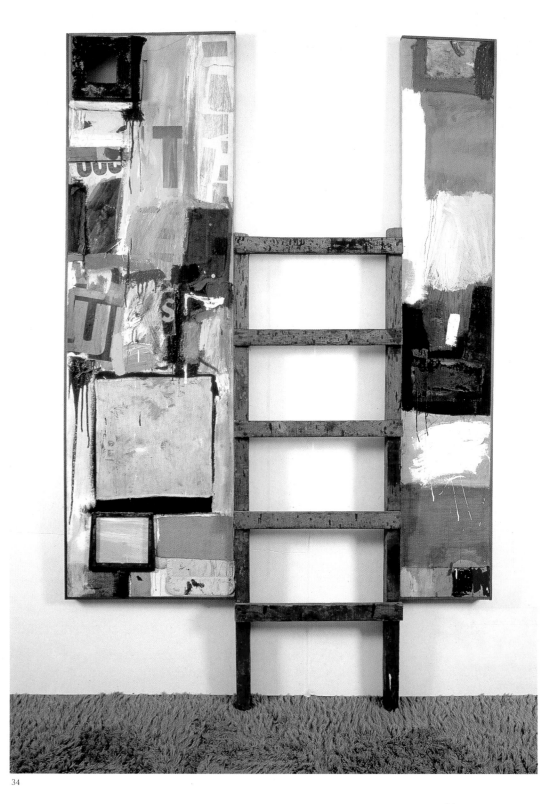

34

34.
Winter Pool, 1959.
Combine painting: oil, paper,
fabric, wood, metal, sandpaper,
tape, printed paper, printed
reproductions, handheld
bellows, and found painting,
on two canvases, with ladder,
90×59¹/₂×4 in.
(228.6×151.1×10.2 cm) overall.

form and color, all come from the real world, and emphatically so. In his earliest expressions, the Blueprints, the White and Black Paintings, and his environmental structures, with all their unexpected aspects, his lived reality is their subject. In his Combines, from 1953 onward, bits and pieces of the world, events, people, telling details from the print media, seem to rush together in a breathless jumble of open-ended collaboration, thrown onto canvas from all directions in a whirlwind of energy and inchoate reaction.

They are filled with contradictions, the most basic of them being their apparent indifference to their situation and juxtapositions. Rauschenberg offers massive accumulations of visual information, apparently undigested, but in the context of the picture plane, and the realm of art, they reconfigure themselves and encourage interpretation, the universal quest for symbol and metaphor. On the other hand, they also exist in a more neutral environment, without any particular emotional charge and available to anyone who wants to interact with them. They are finally esthetic objects, and thus traditional works of art. But, as the painter Tworkov noted, they are also conceptual. Documents, visions and ambiguous images and texts, they are works in progress, one-of-a-kind, catalytic performance pieces that might have been predicted to a degree, given their maker's personality and experiences, and the time that produced them.

When Rauschenberg left Port Arthur in the fall of 1943, he had been making art of a modest, informal character, for some time. He had sketched cartoon characters, taken from the popular press in an oddly prescient way that anticipated pop art's interest in vulgar commercial imagery, and he had collaborated in the theater. But it never had occurred to him that making art might be a serious occupation, and that a life in art could become a conscious career choice. Even now he says that he has difficulty perceiving art as something worthy of extended discussion, something to fret or to groan about. For him art is simply a natural activity, a "means to function thoroughly and passionately in a world that has a lot more to it than paint."[17] From his first days in New York, in 1948, he was puzzled and offended by the prevailing Sturm und Drang over art.

He was perplexed particularly by the notion of an emotional art that bared the soul, he said. "There was something about the self-confession and self-confusion of abstract expressionism—as though the man and the work were the same—that personally always put me off because at that time my focus was in the opposite direction."

"There was a whole language that I could never make function for myself; it revolved around words like 'tortured,' 'struggle,' 'pain'. . . . I could never see these qualities in paint—I could see them in life and art that illustrates life. But I could not see such conflicts in the materials and I

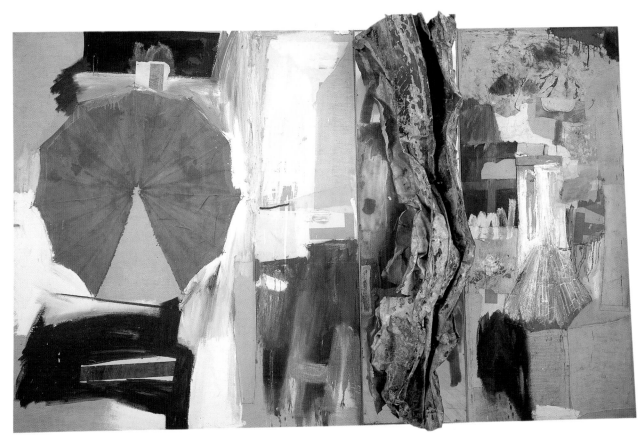

35

35.
Allegory, 1960.
Combine painting: oil, paper,
fabric, printed paper, wood,
and umbrella on three
canvases, and metal, sand,
and glue on mirrored panel,
72¼×114½×11¾ in.
(183.5×290.8×29.8 cm)
overall.

knew that it had to be in the attitude of the painter."[18] Clearly, for Rauschenberg art and life were inseparable all along, with neither reflecting or depending on the other though divided by a gap he saw and understood. His poetic accent was urbane, gentle and elusive by comparison with that of the contemporary Beats. "I used to think of that line in Allen Ginsberg's 'Howl,' about 'the sad cup of coffee,'" he said.

"I've had cold coffee and hot coffee, good coffee and lousy coffee. But I've never had a sad cup of coffee."[19]

At the University of Texas in 1943, however, he was involved with other subjects. He had given up his plan for a life in the ministry at age 13, though he continued to attend church services until after the war, and began studying pharmacy. Within six months he had been expelled, however, for refusing to dissect a frog in anatomy class; soon afterward, he was drafted into the Navy and sent to basic training in Farragut, Idaho. He was voted honor man, but once again found his principles standing in the way of traditional success. Rauschenberg announced that he wouldn't kill anyone, and so he ended up not at the front but with the Navy Hospital Corps in San Diego, as a neuropsychiatric technician.

For two and a half years, he worked on the wards in various California hospitals; during his free time Rauschenberg hitchhiked up and down the coast. It was a difficult time, but one filled with important lessons for the corpsman, who had begun to realize that a skill he had assumed everyone possessed—the ability to draw—set him apart from others. At boot camp in Idaho, he had sketched at night in the latrines, the only place with lights on. During his days on the wards, he saw that war is a tremendously destructive force. "No, I was not forced to fight.

"What I witnessed was much worse. I got to see, every day, what war did to the young men who barely survived it. I was in the repair business," he recalled. "Every day your heart was torn until you couldn't stand it. And then the next day it was torn up all over again. And you knew that nothing could help. These young boys had been destroyed."[20]

Out of the suffering, however, Rauschenberg also refined the idea of balancing a peculiar set of opposites. As he would with the line between life and art, he understood the value of finding and essentially erasing another thin division. "I learned how little difference there is between sanity and insanity and realized that a combination is essential," Rauschenberg has said of his days on the neuropsychiatric wards.[21] Around that time, another revelation helped change the course of his life. He had heard that there were fine cactus gardens in San Marino, and he wandered from the gardens next door to the Henry E. Huntington Library.

There he saw two paintings he recognized from reproductions on the backs of playing cards: Sir Thomas Lawrence's *Pinkie* and Thomas Gainsborough's *The Blue Boy* Rauschenberg was "very shook up"[22] by the

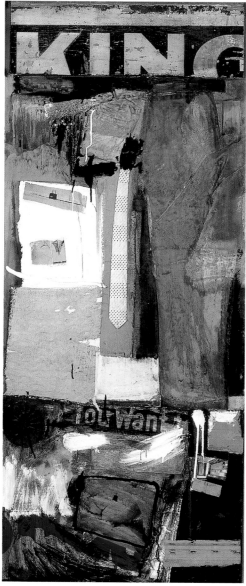

36

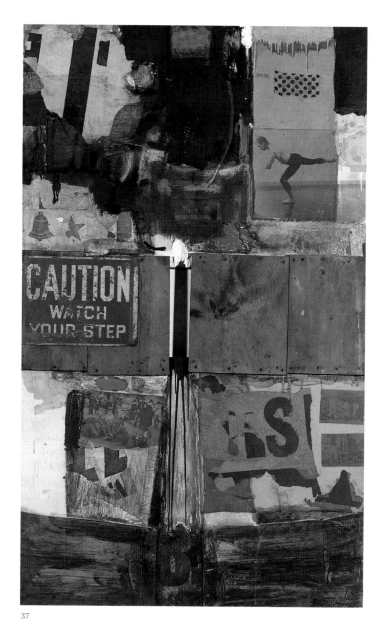

37

36.
Kickback, 1959.
Combine painting,
76 ¹/₂×33 ¹/₄×2 ³/₄ in.
(194.3×84.4×7 cm).

37.
*Trophy I (for Merce
Cunningham)*, 1959.
Combine painting, 66×41 in.
(167.6×104.1 cm).

38.
Canto VI, 1958.
(From "Thirty-Four Drawings
for Dante's 'Inferno'").
Solvent transfer on paper,
with gouache, pencil,
watercolor, and wash,
14¹⁄₈×11¹⁄₂ in. (36.5×29.2 cm).

39.
Canto VIII, 1959–60.
(From "Thirty-Four Drawings
for Dante's 'Inferno'").
Solvent transfer on paper,
with pencil, watercolor,
gouache, and crayon,
14¹⁄₂×11¹⁄₂ in. (36.8×29.2 cm).

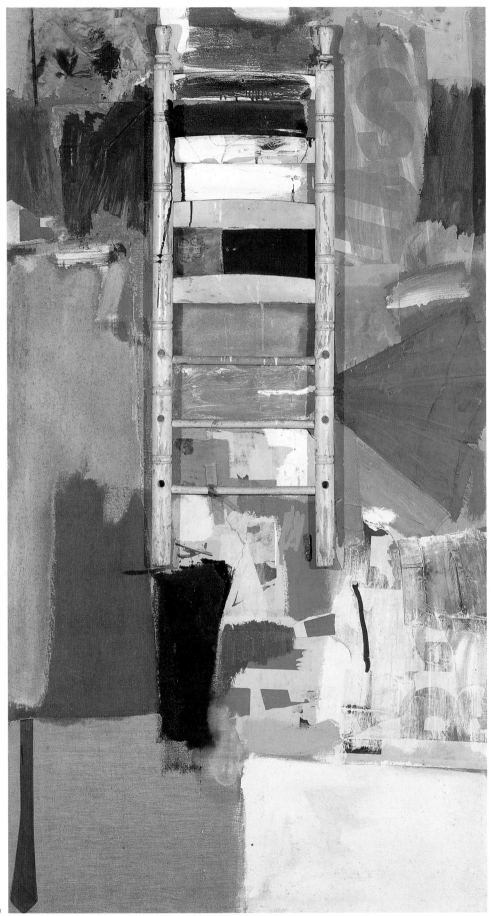

40

40.
Octave, 1960.
Combine painting,
78×43 in.
(198.1×109.4 cm).

paintings, not so much for their esthetic qualities as for their subject matter, and seemingly magical powers of factual representation. "This was my first encounter with art as art,"[23] he said. When he understood that "somebody actually MADE those paintings [it] was the first time I realized you could be an artist."[24]

After his honorable discharge from the Navy in 1945, he returned to Port Arthur to visit his family. But, as has been so often recounted, he didn't find anyone at home—his family had moved away without telling him "to Lafayette La. with sister, Janet, Born Apr. 23, 1936. After Navy: returned home, left home. Worked in Los Angeles. Moved to Kansas City to study painting K.C.A.I.," he noted tersely in the remarkable spiral of text on his vertical print, the 1968 *Autobiography*.

His move to the Kansas City Art Institute came about serendipitously; while working as a packer at the Ballerina Bathing Suit factory in Los Angeles, he met a bathing suit designer, Pat Pearson, who was the first to seriously encourage his interest in art. Rauschenberg followed his new girl friend home when she returned to Kansas in 1947; he had worked as a movie extra to save money for his fare, and arrived at the Kansas City bus station too early in the morning to call her. While he waited for the dawn, Rauschenberg decided that his new life as an artist should include a new first name, and he chose Robert, his German grandfather's name.

After a year in Kansas, learning as much outside the Kansas City Art Institute as in it, he has said,[25] he decided to study in Paris, and set sail on a converted troopship. There he found a Paris that had not recovered from the war, a dispiriting Academie Julian, a city rich with evocative debris and, most promising, another art student named Sue Weil.

Life at the academy in Paris with Weil ("we each agreed that the other was the worst artist in the class"[26]) was different from anything he had known. "The criticism was once a week in French, and I didn't understand any French," he recalled. "The other students were hung up on whether their stuff should look like Matisse or Picasso. I saw my first Matisses and Picassos in Paris, but they didn't really make much sense to me. I simply wanted to learn to paint."[27]

It was a heady time, though perhaps their most innovative work came in the front room of their pension, where Rauschenberg was so enamored of his medium that he often painted with his hands, palms, even fists. The young artists occasionally spilled pigments on the pension's worn oriental rug and, to keep the concierge happy, they balanced each spill with its own dab of fresh paint. They left the academy, wandered the streets, free to develop their own styles and pick up impressions, and worked at the pension. By the summer of 1948, Rauschenberg decided that he needed discipline, and he thought he knew where to find it. He had read about

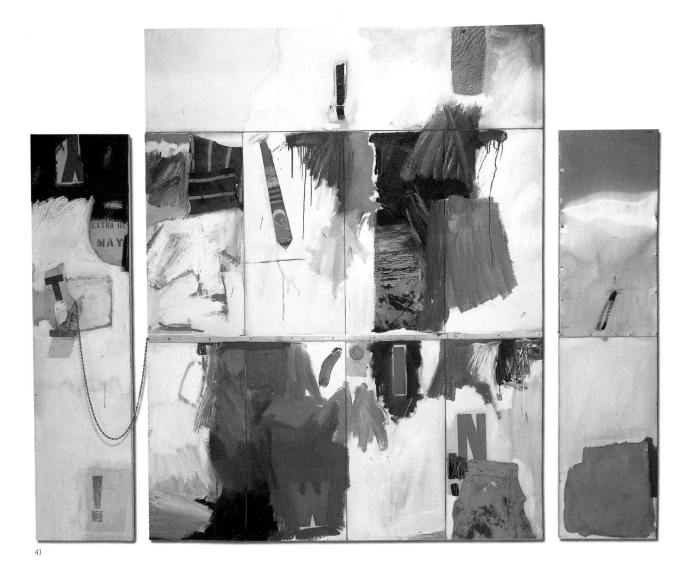

41

41.
Trophy II
(for Teeny and Marcel Duchamp), 1961.
Combine painting: oil, charcoal, paper, fabric, printed paper, printed reproductions, sheet metal spring on seven canvases, with chain, spoon, and water-filled plastic drinking glass on wood,
90×103×5 in.
(228.6×274.3×12.7 cm) overall.

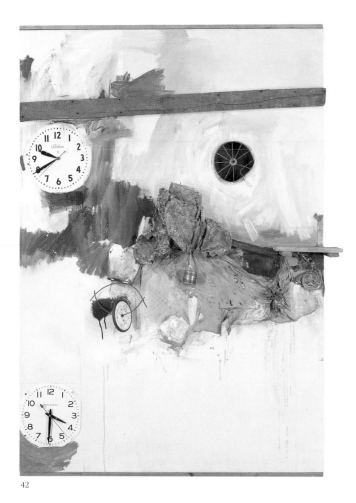

42

43

42.
Reservoir, 1961.
Combine painting,
85¹/₂×62¹/₂×14³/₄ in.
(217.2×158.8×37.5 cm).

43.
Second Time Painting, 1961.
Oil and assemblage on
canvas, 66×42×4 in.
(167.6×106.7×10.2 cm).

Black Mountain College, a little known avant-garde school of the arts in the mountains of western North Carolina. There the former Bauhaus designer and painter Josef Albers was the head of its fine arts department and was considered "the greatest disciplinarian in the United States," according to *Time* magazine.

Coincidentally, Weil already was planning to enroll at Black Mountain, and Rauschenberg decided to join her. He saved money for his passage, and began his training with Albers in the middle of the 1948 fall semester. The Bauhaus master embodied order, and he viewed art's elements in a way that was completely counter to the emerging Rauschenberg esthetic. "Albers's rule is to make order. As for me, I consider myself successful only when I do something that resembles the lack of order I sense," the younger artist has said of the teacher who would walk into the classroom, glance at Rauschenberg's work and usually refuse to critique it, since the inchoate results seemed so counter to his own rigid precepts for art.

Despite these painful slights, Rauschenberg spoke generously of his teacher. "Albers was a beautiful teacher and an impossible person," he said. "He wasn't easy to talk to, and I found his criticism so excruciating and so devastating that I never asked for it. Years later, though, I'm still learning what he taught me, because what he taught me had to do with the entire visual world. He didn't teach you how to 'do art.' The focus was always on your personal sense of looking. . . . I consider Albers the most important teacher I've ever had, and I'm sure he considers me one of his poorest students."[28]

Rauschenberg grows pensive, if not rueful, when he recalls Albers's assessment. "Coming from Paris, entering in the middle of the term, and showing all that wildness and naiveté and hunger, I must have seemed not serious to him, and I don't think he ever realized that it was his discipline that I came for. Besides, my response to what I learned from him was just the opposite of what he intended. . . . I was very hesitant about arbitrarily designing forms and selecting colors that would achieve some predetermined result, because I didn't have any ideas to support that sort of thing—I didn't want color to serve me, in other words. That's why I ended up doing the all-white and the all-black paintings—one of the reasons, anyway."[29]

By the time he left Black Mountain, in the summer of 1949, he was launched in the radical direction of his severe monochromatic exercises and his enduring role as a groundbreaking, iconoclastic artist and spontaneous performer. Those monochromatic paintings, like the Red Paintings that soon followed—mixed-media collages that extended aggressively into the spectator's space—literally erased the traditional

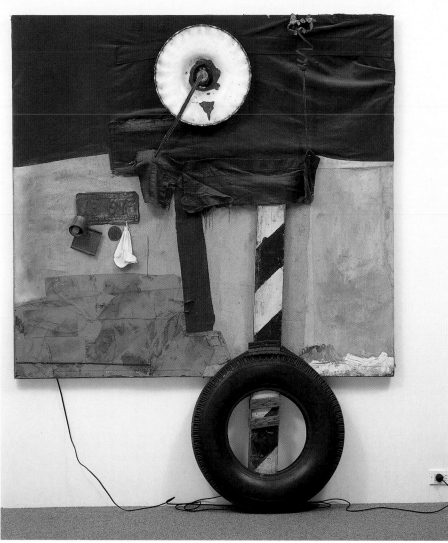

44.

44.
First Landing Jump, 1961.
Combine painting: cloth,
metal, leather, electric
fixture, cable, and oil paint
on composition board; with
automobile tire and wooden
plank, 89⅛×72×6⅝ in.
(226.4×182.8×16.8 cm).

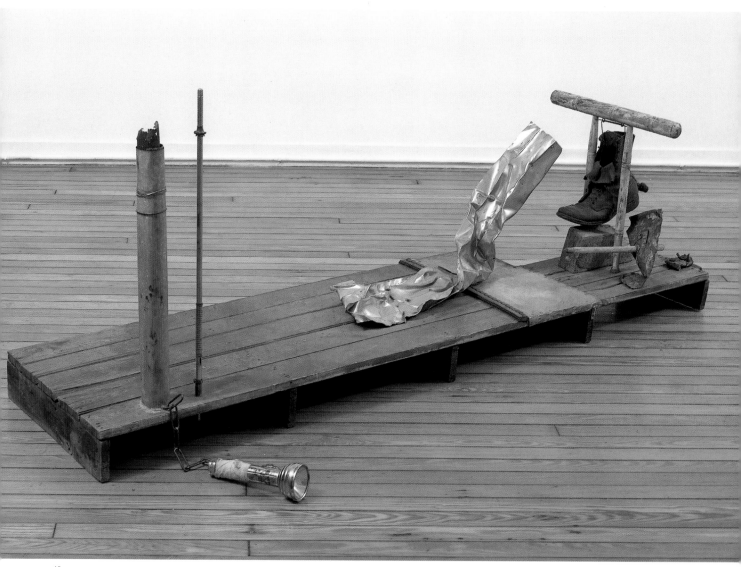

45

45.
Trophy IV (for John Cage),
1961.
Combine: metal, fabric,
leather boot, wood, and tire
tread on wood, with chain
and flashlight, 33×82×21 in.
(83.8×208.3×53.3 cm).

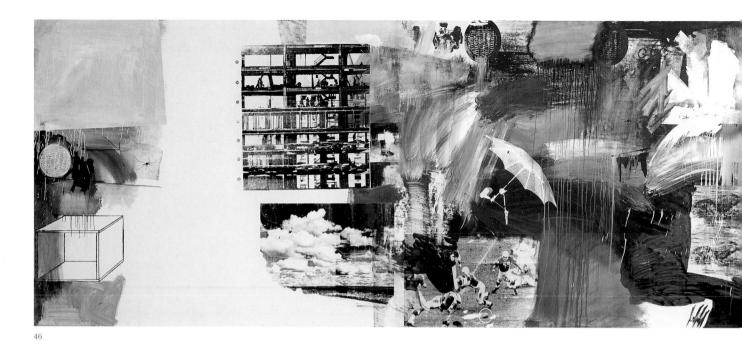

lines between art and life, and outraged most of the art world, earning Rauschenberg the reputation of *enfant terrible*. At the same time, those works won him the admiration of some respected art world figures, like Tworkov, who recognized his originality and immense promise.

Rauschenberg returned to New York that summer, feeling less like a "hick" than he had the year before. Indeed, he and Weil had become inseparable in Paris and had retained that closeness in the rich ferment that was vanguard Black Mountain College in its brief prime. He had become such an intimate part of the Weil family that when her parents suggested there might be talk if they did not form a more traditional alliance than their easy-going companionship, he proposed marriage, appropriately enough, on the spur of the moment, and in a soda shop.

Their wedding was at the Weil home off the Connecticut coast, and both bride and groom wore white. In his terse, though poetic autobiography, the ceremony is sandwiched between other key transitions in an increasingly wide-ranging, collaborative life: "1948 Black Mountain College N.C. Disciplined by Albers. Learned photography. Worked hard but poorly for Albers. Made contact with music and modern dance. Felt too isolated, Sue and I moved to NYC. Went to Art Students League. Vytlacil & Kantor. Best work made at home. Wht. painting with no's best example. Summer 1950, Outer Island Conn. Married Sue Weil. Christopher (son) Born July 16, 1951 in NYC. First one man show Betty Parsons's."[30]

At the well-known, rather traditional Art Students League he absorbed the lessons of his masters, Morris Kantor and Vaclav Vytlacil, and

46.
Barge, 1962–63.
Oil and silkscreened ink on canvas, 79⅞×386 in. (203×980.44 cm).

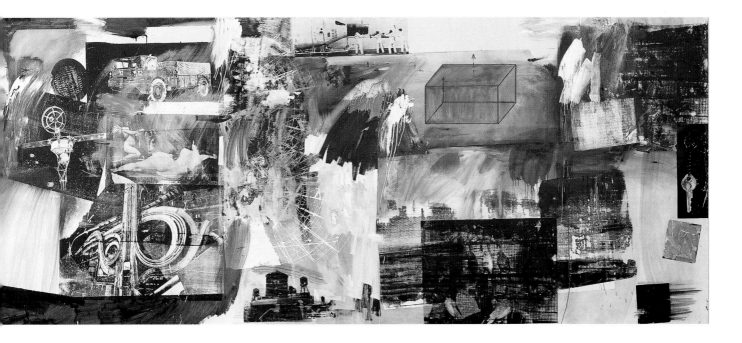

continued explorations on his own in a limited way, first in a rented studio and then in the larger Willett Street space, in a building without heat or water. He and Weil also roamed Manhattan, visiting the small art scene that included a handful of significant galleries and artists. At Betty Parsons's space on 57th Street, they saw the aloof, intimidating abstract works of Jackson Pollock, Barnett Newman, Clyfford Still, Hans Hofmann, Mark Rothko, Adolph Gottlieb and Ad Reinhardt. Rauschenberg explored and assimilated, juxtaposing intuitively the gestural expressionist works he saw with the restraint he had observed in Albers's gridded structures.

One day in the fall of 1950, he and Weil walked boldly into Betty Parsons's gallery, carrying as many of Rauschenberg's paintings as they could manage to hold. Many of them were from the recent, religiously oriented series that included the rough, disarmingly direct *Garden of Eden*, *Crucifixion and Reflection* and *Trinity*. Kantor had urged his student to approach Parsons, and he did so shyly and with great trepidation. To date, he had shown only his Blueprints, works that appeared in a *Life* magazine feature, "Speaking of Pictures." And some Blueprints had appeared in windows Rauschenberg dressed for commercial designer Eugene Moore at Bonwit Teller, in what was arguably his first New York "show." Also working in his favor was the inclusion of *Blueprint: Photogram for Mural Decoration* in the Museum of Modern Art's spring show of 1951, "Abstraction in Photography."

Still, the couple had no particular hope of winning Parsons's favor, particularly in light of the ongoing misunderstanding of Rauschenberg's

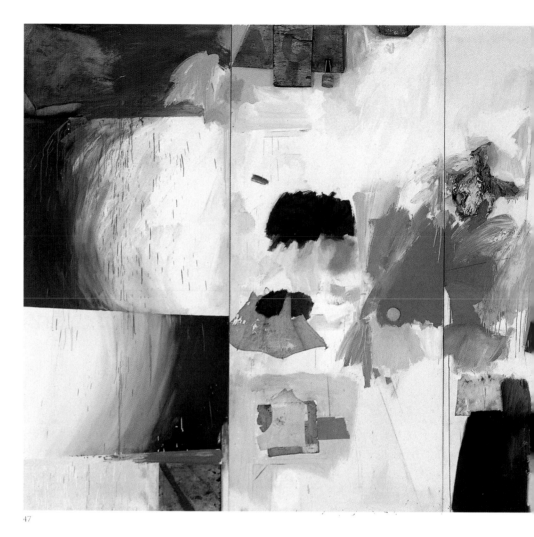

47

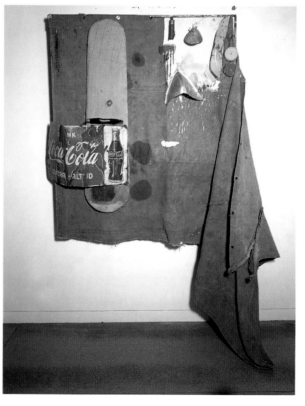

47.
Ace, 1962.
Combine painting,
108×240 in. (274.3×609.6 cm).

48.
Dylaby, 1962.
Combine painting,
109¹/₂×87×15 in.
(278.2×221×38.6 cm).

49.
Kite, 1963.
Oil and silkscreened ink on
canvas, 84×60 in.
(213.4×152.4 cm).

48

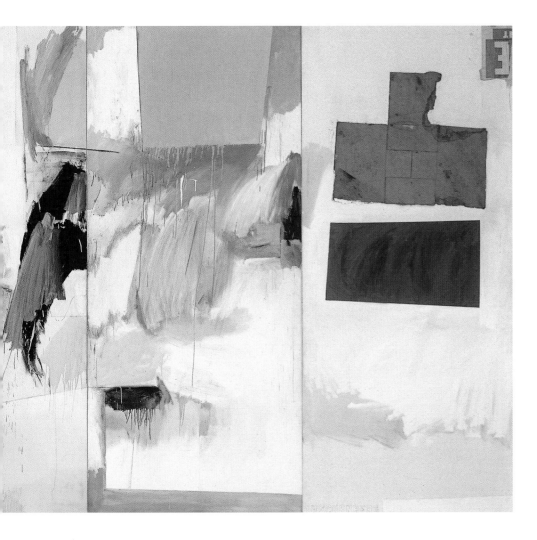

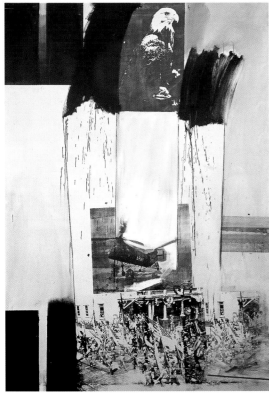

49

seriousness. Such works as his painterly *22 The Lily White* and a more conceptual piece that he created by laying butcher paper on the floor at an Art Students League entrance to document the imprint of foot traffic had earned him a reputation as, to put it mildly, facetious. And his compositions on blueprint paper, free but tied to its commercial application, hardly helped. But after being initially taken aback, Parsons looked at the young artist's work that day in 1951, several months before the birth of his son Christopher and the collapse of the Rauschenberg marriage. The legendary Betty Parsons, celebrated among the avant-garde for her keen and unprejudiced eye, liked what she saw, though it would be well over a decade afterward before the wider world would be convinced, and offered him a show.

Soon afterwards, Parsons came to the Rauschenberg's apartment on West 96th Street to select paintings for the show, accompanied by Clyfford Still, who had very little to say and undoubtedly did not participate in making the selection. Typically, Rauschenberg could not leave his work alone and reworked much of the selection, as he tried to make them excel. His exhibition, in the smaller Parsons gallery, behind an exhibit of works by Walter Murch, was rather coldly received. None of its pieces sold, and critical reaction was sparse and chilly (a positive note was struck, perhaps, by *New York Times* critic Stuart Preston, who called them "stylish doodles in black and white."). The exhibit did attract one important visitor: John Cage, the vanguard composer with whom Rauschenberg would collaborate extensively, and whose aleatory art and Zen philosophy would influence the younger artist to a remarkable degree.

After the Parsons exhibition, which presented Rauschenberg to the New York art world, he created his largest works to date. As he gained admission to the more established and prestigious gallery roster, he saw his work included in "Today's Self-Styled School of New York," the Ninth Street Show organized as a survey by The Club 35, a loosely knit group of vanguard artists, performers and writers. Small and mixed though it was, the recognition he was beginning to elicit was of great importance to Rauschenberg. He and Weil returned to Black Mountain again that summer, bringing the newborn Christopher with them. There, as relations deteriorated between the couple, he made such enormous strides with his expanding format and repertoire that Rauschenberg's work was seen not so much as stretching the boundaries of abstraction into another generation but as challenging it.

Besides his tongue-in-cheek, sardonic pieces that evoked Dada but were too good natured to be accused of nihilism, Rauschenberg held some unusual ideas about art. He was drawn to a mystical way of working, as he would be throughout his career, and viewed color and form as mere elements in an infinite palette of formal options that were

50.
Estate, 1963.
Oil and silkscreened ink on canvas, 95¹/₄×69¹/₄ in. (243.2×177.8 cm).

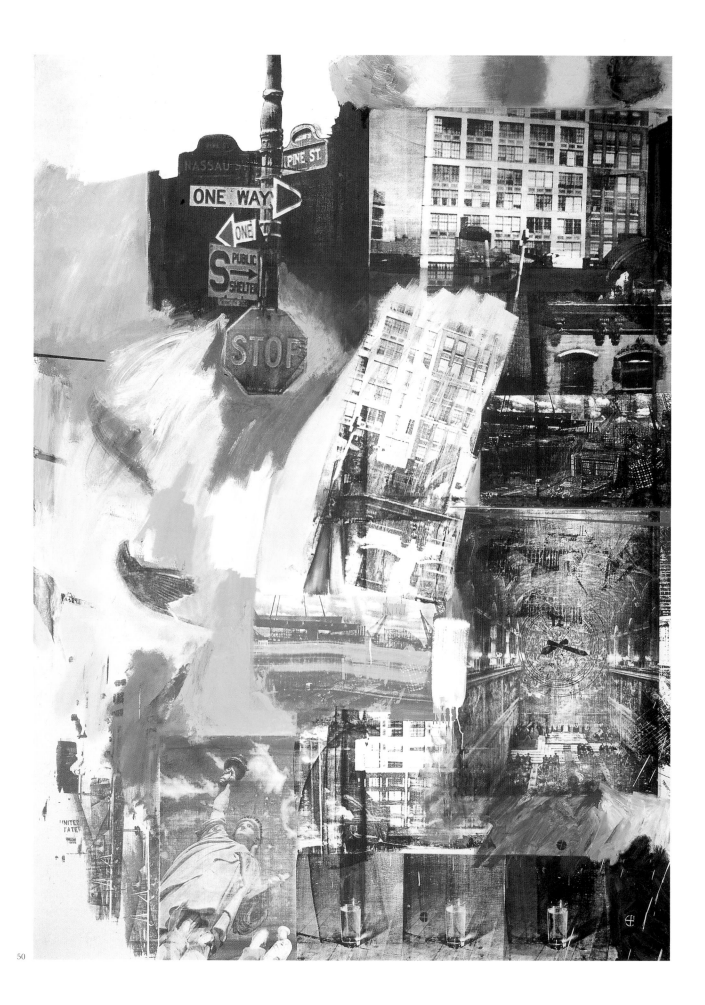

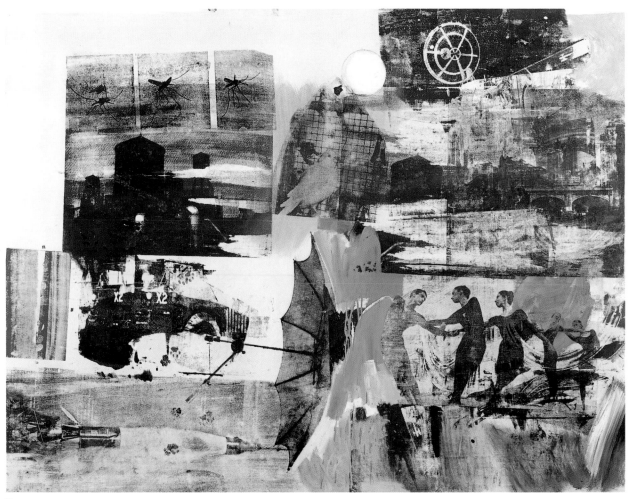

51

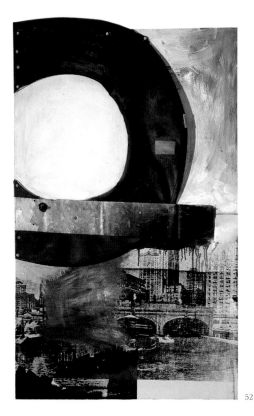

51.
Scanning, 1963.
Oil and silkscreened ink on
canvas, 55 1/4×73 in.
(141.6×185.4 cm).

52.
Tadpole, 1963.
Oil and silkscreened ink on
canvas with inner tube and
other objects, 48×30 1/4 in.
(121.9×76.8 cm).

52

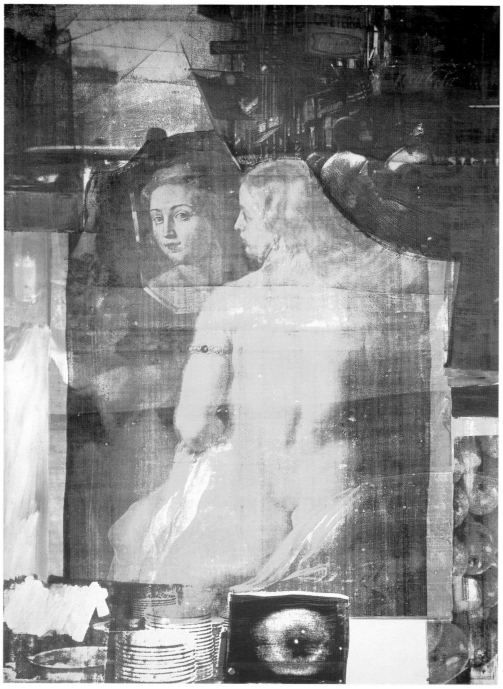

53

53.
Persimmon, 1964.
Oil and silkscreened ink on
canvas, 66×50 in.
(167.6×127 cm).

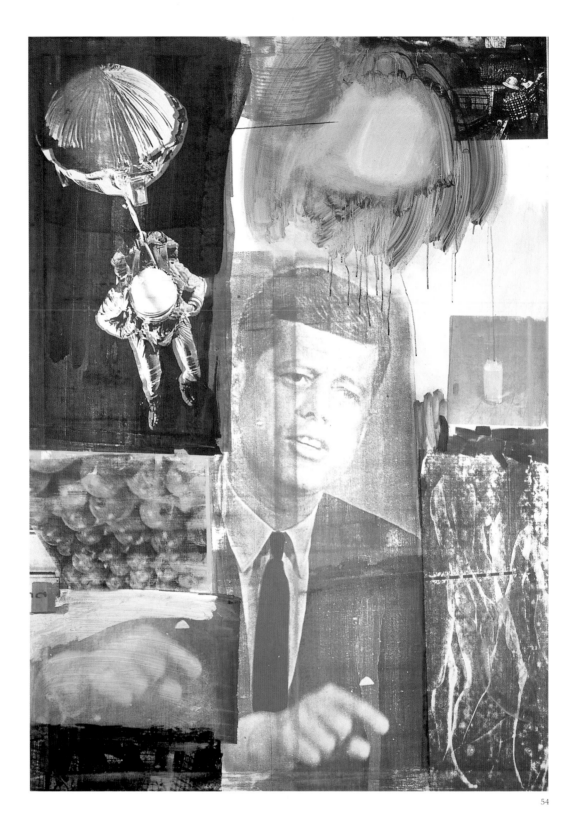

54

54.
Retroactive I, 1964.
Oil and silkscreened ink
on canvas, 84×60 in.
(213.4×152.4 cm).

55.
Quote, 1964.
Oil and silkscreened ink
on canvas, 92×72 in.
(239×183 cm).

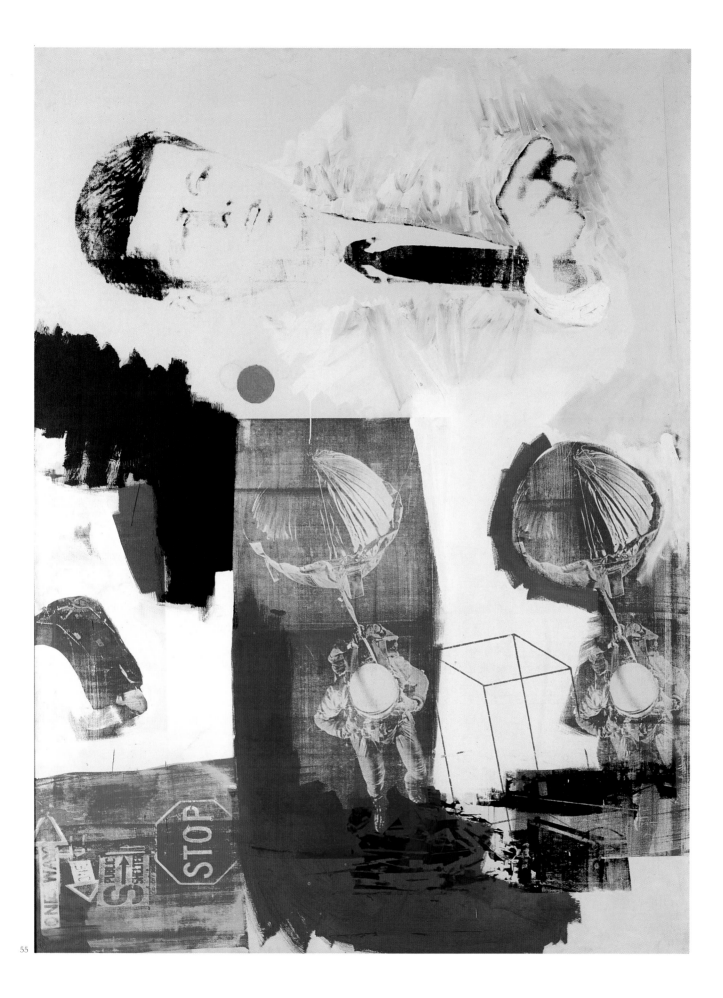

less arbitrary than random. His extreme, principled position was that he could not " . . . design forms and colors that would achieve some pre-conceived result. . . . I wasn't going to hire them. I was more interested in working WITH them than in their working for me," he has explained.[31]

The most restrained works of his oeuvre, the austere but significantly original White Paintings, may have seemed vacuous then, even insulting in their simplicity and implied mechanism. Taken in another light, however, they were brilliantly interactive, and they set the stage conceptually for what would follow. Unlike their presumed predecessor, Malevich's famous *White on White* painting of 1919, the series Rauschenberg pioneered in 1951, in his second period of study at Black Mountain College, was intended as a kind of environmental mirror, a tabula rasa that would reflect whatever came within its ambiance.

The White Paintings initiated Rauschenberg's most important early phase of radical experimentation at Black Mountain College, when he came into direct contact with the fertile ideas of John Cage and Merce Cunningham for the first time. Rejecting Albers's formalist, methodical instruction and his concept of expression as the personal will of the artist, he turned to the ideas of openness and extreme freedom advanced by Cage and Cunningham, fashioning his own breakthrough under their influence. Cage in particular provided him with the model for his themes of "multiplicity, variety, and inclusion," as he later articulated them.

Rauschenberg participated in an historic performance piece, designated as a "concerted action," on which Cage, Cunningham, pianist David Tudor and poet Charles Olsen all collaborated. Rauschenberg contributed a slide show and hung his all-white, modular paintings as background for this eventful occasion that represented an early American attempt to create a theatrical synthesis of the arts. It was the prototype for the later "Happenings" developed by Allan Kaprow, Claes Oldenburg, Jim Dine and others in New York in 1959. These informally staged events broke down traditional genres in art, bridging the barriers between art and life, and making possible soon after the introduction of the signs and objects of popular culture and mass media in the fine arts. They thus paved the way for the eruption of pop art in the sixties.

When first seen in later public exhibitions in New York, the White Paintings which made their debut as part of a collaborative performance, drew a firestorm of outraged criticism, with reviewers dismissing them as "definitive proof of the impossibility of creating a void . . . and practical jokes, anti-art gestures, mere provocations."[32]

Rauschenberg was stunned by the reactions to the White Paintings, which he considered typical of his work, and neither a joke, gesture nor deliberate provocation of any kind. Programmatic concept painting was alien to him; none of his work, he has said, has ever started with an a priori idea.

56.
Oracle, 1962–65.
Five-part found-metal assemblage with five concealed radios: ventilation duct; automobile door on typewriter table, with crushed metal; ventilation duct in washtub and water, with wire basket; constructed staircase control unit housing batteries and electronic components; and wood window frame with ventilation duct. Installation dimensions variable.

57.
Mainspring, 1962–65.
Solvent transfer on paper, with pencil, watercolor, gouache, cardboard, and tape, 32×62½ in. (81.3×158.8 cm).

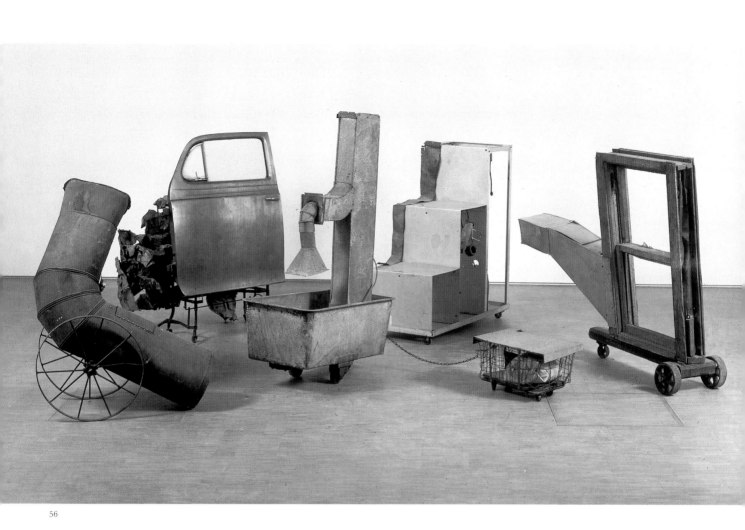

56

57

For him, the White Paintings were "not passive but very—well, hyper-sensitive. . . . One could look at them and almost see how many people were in the room by the shadows cast, or what time of day it was."[33] The flat, blank White Paintings were contemporaneous with the seemingly antithetical Black Paintings, an equally modular series but finished with different surface qualities and textures. He began them by crumpling newspapers and pasting them onto canvas "to make a lively ground, so that whatever I did would be in addition to something that was already there, so that even the first stroke in the painting would have its position in a gray map of words," he has said.

"With the black ones I was interested in getting complexity without their revealing much—in the fact that there was much to see but not much showing. I wanted to show a painting that could have the dignity of not calling attention to itself. In both the blacks and the whites there was none of the familiar aggressiveness of art that says, 'Well, here it is, whether you like it or not.'"[34]

Indeed, it hardly mattered to Rauschenberg whether anyone did or did not like his work; more, whether it had any impact at all. To him, the artwork was not about an object. It was about process and, ultimately, collaboration—in this case, collaboration among the various elements, between artist and elements and, notably, between all of the above and viewers. In such a light, it's easy to see why the White Paintings, in their modular variety and infinite expandability, suited his purposes at that moment. What is difficult to understand is what induces Rauschenberg to abandon one series so quickly at times in order to move on to new conquests. Some creative compulsion drives him forward to explore new ground, and never to repeat past experiments. He met Cage again in Black Mountain that momentous summer, as the White works gave way to Black, and to a new set of visual challenges. Rauschenberg was profoundly influenced by the composer's Zen theories and his interdisciplinary approach, to art and to life.

For his part, Cage was drawn to the young artist's nonchalance and originality, and to the freewheeling, anti-traditional, unencumbered outlook he had personally evolved. The radical vacancy of the White Paintings, which had been important elements in the *mis-en-scène* of his collaborative summer performance piece, particularly fascinated Cage. The composer later described the painting series as "airports for lights, shadows, and particles,"[35] and they directly inspired his famously disconcerting 4'33", a musical composition in three movements interpreted by Tudor sitting aloofly at a piano keyboard with which his fingers never made contact for an excruciatingly long and silent interval, thereby constituting the substance of the work. The composer later collaborated

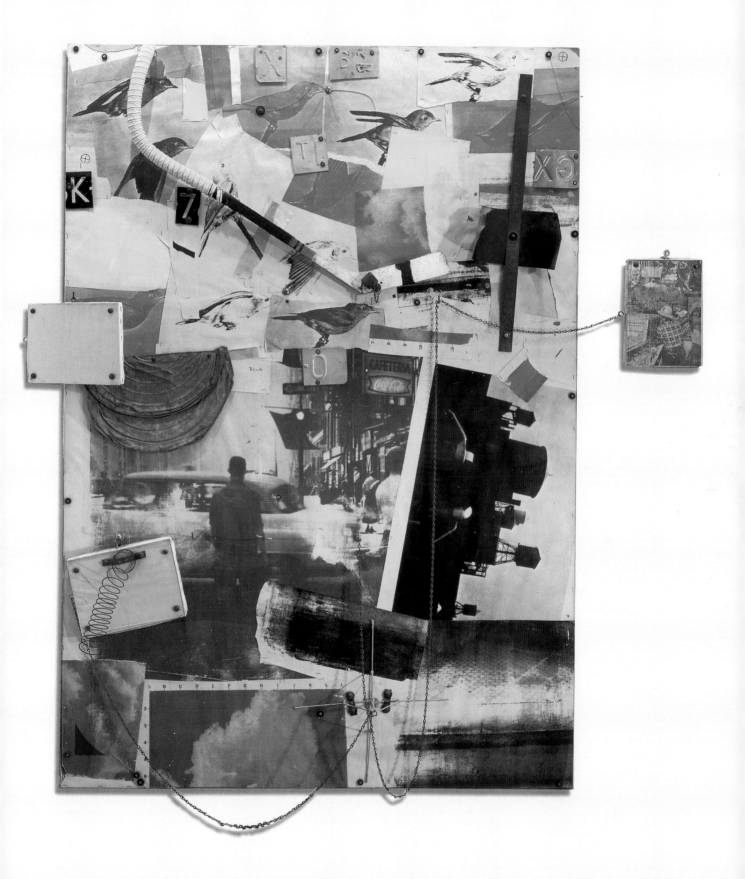

with Rauschenberg on his *Automobile Tire Print* in New York City in 1953, outside his Fulton Street Studio. Composer and artist matched wits about their respective roles and the relative merits of conceiving and creating the piece. "He did a beautiful job, but I consider it my print," the artist insisted. Cage good naturedly refused to surrender his claim as performer: "But which one of us drove the car?"

These radically anti-art pieces, with their additional emphasis on collaboration, whimsy and chance, echoed the ideas of Marcel Duchamp, the dada sage, ingenious trickster and conceptualist who was alive and well in New York at the time, although ostensibly no longer producing art. His legendary explorations with chance, the designation of commonplace manufactured objects as art in the form of his designated "ready-mades," and his many acute observations on the problem of art and anti-art were particularly influential on Rauschenberg; even today they continue to shape the conceptions of contemporary art. Duchamp felt that no two people ever see an artwork in the same way. Thus the audience becomes a vital element in the meaning of the work. "The spectator experiences the phenomenon of transmutation; through the change from inert matter into a work of art, an actual transubstantiation has taken place," Duchamp explained.

"All in all, the creative act is not performed by the artist alone; the spectator brings the work into contact with the external world by deciphering and interpreting its inner qualifications and thus adds his contribution to the creative act."[36]

In the late summer of 1952 Rauschenberg left Black Mountain College for Italy with painter Cy Twombly, whom he had met at the Art Students League and whose grant (from the Virginia Museum of Arts) to travel in Europe the two shared. They traveled in Italy, France and Spain before their funds began to run out. Rauschenberg had brought $300; he had just $50 left when his life took another major, if random, turn. He heard of an American building contractor working in North Africa, paying princely wages; Rauschenberg, through another round of peculiar twists and turns, went a work for a construction company in Casablanca and within two months had saved enough to underwrite the remainder of his first European sojourn.

Twombly joined him in North Africa and the two traveled to the edge of the Sahara and went to Morocco, taking copious photographs and collecting the regional debris. Interesting objects—bones, sticks, fur, hair, bits of broken fixtures, feathers, rocks, shells—ended up in a collection of small, lyrical sculptures in box form. Curiously like Joseph Cornell's boxes, which Rauschenberg had not seen, however, the younger artist's work is nonetheless more outgoing and expansive, tied to external stimulae.

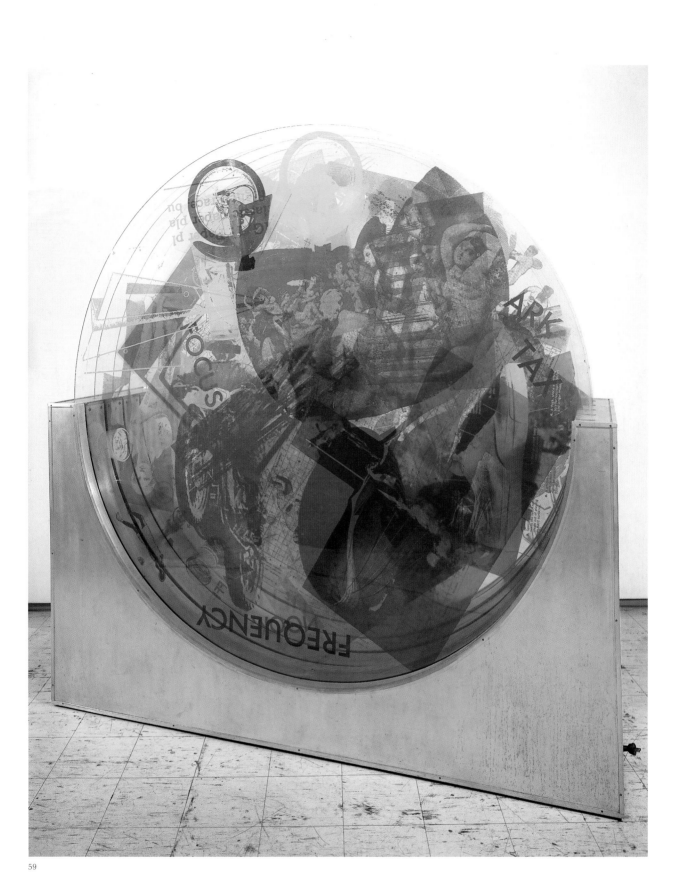

59

59.
Revolver, 1967.
Silkscreened ink on five
rotating Plexiglas discs in
metal base, with electric
motors and control box,
78×77×24¹/₂ in.
(198.1×195.6×62.2 cm).

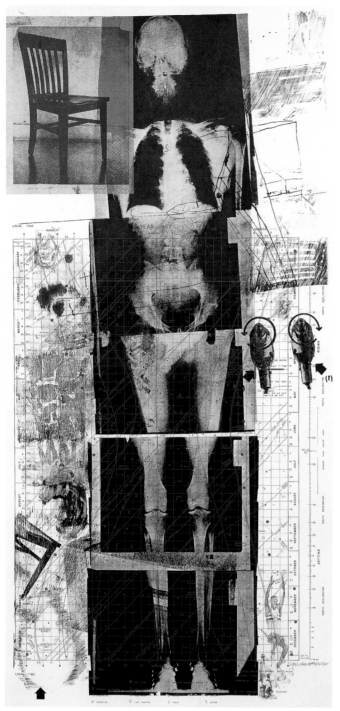

60

61

60.
Booster, 1967.
Color lithograph and
silkscreen on paper,
72×25½ in. (182.9×90.2 cm).

61.
Soundings, 1968.
Mirrored Plexiglas and
silkscreened ink on
Plexiglas, with concealed
electric lights and electronic
components, 94×432×54 in.
(238.8×1,097.3×137.2 cm).

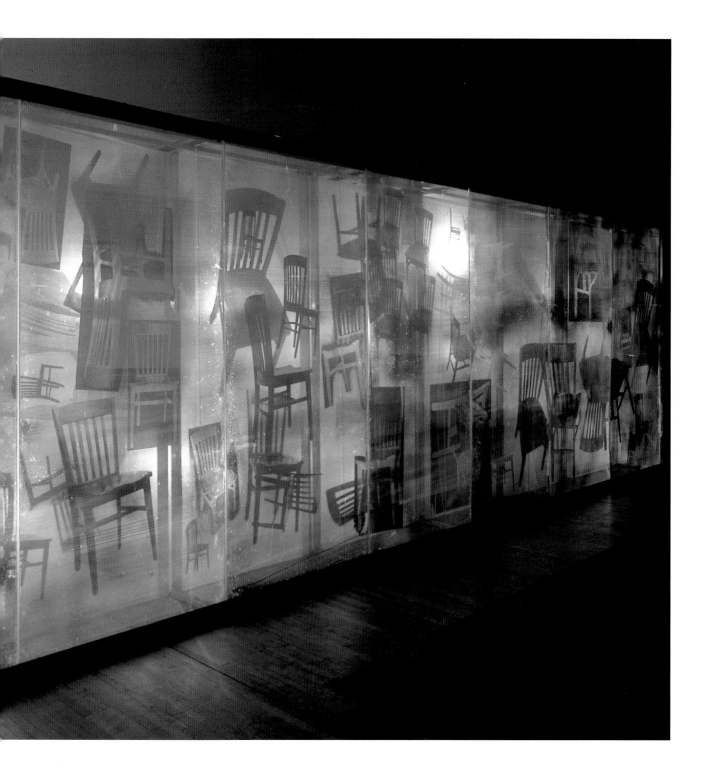

Synergistic and iconic, they were shown as *Scatole e feticci personali* at the Galleria dell'Obelisco in Rome, and the collection was later shown again in the spring of 1953 at the Galleria d'Arte Contemporanea in Florence.

The show of "meditative boxes and personal fetishes," was viewed as a deliberate act of defiance, or a bad joke by everyone, the dealers included, Rauschenberg later recalled. When one disgusted Florentine critic even suggested the boxes be thrown into the Arno, Rauschenberg surprisingly obliged at the close of the exhibition. Drowning the boxes became a liberating response to critical slurs, but even more interestingly, it forced a sly collaboration, implicating the critic in a new composite work-cum-performance. Rauschenberg acted on the critic's intemperate dismissal not so much impulsively as deliberately, in the framework of a conceptual act. He conscripted, and thereby assimilated, a hostile critic into the work he disliked so intensely and, with considerable beau geste, actually threw the boxes into the Arno as commanded, weighted so none would ever resurface. Ironically enough, the few boxes that were sold, or retained by the dealer, later resurfaced in the art market where they commanded substantial prices, as Rauschenberg's reputation rose to stardom. Such tales only added more luster to his rapidly growing, and to some degree cultivated legend of the prodigal youngster.

In 1953, back in New York once again, Rauschenberg and Twombly managed to place their works in an exhibition at the Stable Gallery. Besides the White Paintings and Black Paintings, Rauschenberg exhibited the rock-and-wood works closely related to his European sculptures. He had moved into a new studio that spring, a space on Fulton Street with ceilings high enough for monumental works. There he began his "red" paintings, his first so-called "combines" in the Rauschenberg vernacular, mixing form, texture, tone and media with non-art materials salvaged from the streets, as he enlarged concept and imagery into untried formal configurations and dimensions. He was still impoverished: his rent on Fulton Street was $10 a month, his daily food budget, literally 15 cents; a bucket in the yard was his sink, and he learned to take lightning-quick showers at friends' homes. He had ample space to work in, however, and his paintings flourished. Rauschenberg's waterside location in downtown Manhattan was remote from other artists, but he became attached to the area, particularly to the disjunctive skyline profile with its resplendent new skyscrapers of the financial district and old, weathered wooden houses side by side.

He particularly liked the abundant abandoned debris available in his neighborhood, with its juxtapositions and its contrasts. For Rauschenberg it was vital, pungent, as immensely varied as the art he tried to bring together from diverse elements including the detritus of the real world. The incorporation of this debris, and eventually also rags and tatters of cloth, reproductions from the print media, fragments of comic strips, and other

62

63

62.
Signs, 1970.
Silkscreened print (edition of
250, Castelli Graphics),
43×34 in. (109.2×86.3 cm).

63.
Brick, 1970.
Cut-and-pasted newspaper on
paper, with watercolor, gesso,
and pencil, 40×27 1/2 in.
(101.6×69.9 cm).

collage elements of waste and discarded street materials brought a dadaist intensity to his work of the early fifties, and seemed to challenge all established esthetic precepts. The idea of completely eliminating taste also led him to buy cans of unlabled paint. The first batch was a vibrant red, as it turned out, a color he found very difficult to work with because it was so aggressive, but he persisted nonetheless and did a number of powerful works.

Yoicks was characteristic, a loaded red collage of 1954; its gaudy bands of polka-dotted fabric seem glued to one another and to the bright bars of pigment by a randomly drippy series of painterly slashes reminiscent of De Kooning's febrile brushstrokes. He worked the densely packed surfaces of these so-called "combines" over with paint in the characteristic, spontaneous gestural language of action painting, but painterly expressiveness enjoyed reduced powers and prerogatives in an artistic structure choked with alien matter. In describing this method of creation as a collaboration with materials, the artist made an oft-quoted statement that became a slogan of the radical new realism, as this phenomenon was once known especially among Europeans: "Painting relates to both art and life. Neither can be made. (I try to act in the gap between the two.)"[37]

In turning from small and somewhat precious collage paintings to more expansive and ambitious "combine" paintings, Rauschenberg challenged current assumptions about what materials were or were not suitable for art. *Hymnal,* of 1955, is a major combine painting in which the extent of the paint surface has been radically reduced and redefined in favor of an intrusive agglomerate of charged object and material fragments. Rauschenberg covered the canvas with a paisley-patterned shawl, which acts as a decorative paint ground and creates an active and resonant surface that interacts dynamically with the other elements. Although there is no clear narrative message, a kind of thematic consistency emerges in the *Wanted* poster and its catalogue of dangerous and criminal traits, the arrow pointing to an image of a fallen person, a scratched book cover, and a fragment of a Manhattan telephone directory—all suggesting the delinquent and disenfranchised aspects of modern urban existence. The artist's hand and visible touch intrude selectively, but do little to clarify the narrative content, leaving the challenge of deciphering meanings to the viewer. Maintaining this openness to the viewer's response and interaction is a major and controlling element in Rauschenberg's aesthetic. Evolved from clues suggested by Schwitters's *Merzbild* trash constructions and De Kooning's energetic paint swipes (and his feeling for popular imagery, especially in his Woman series), Rauschenberg's innovative assemblages were critical influences in the radical changes that took place in American art in the middle and late fifties.

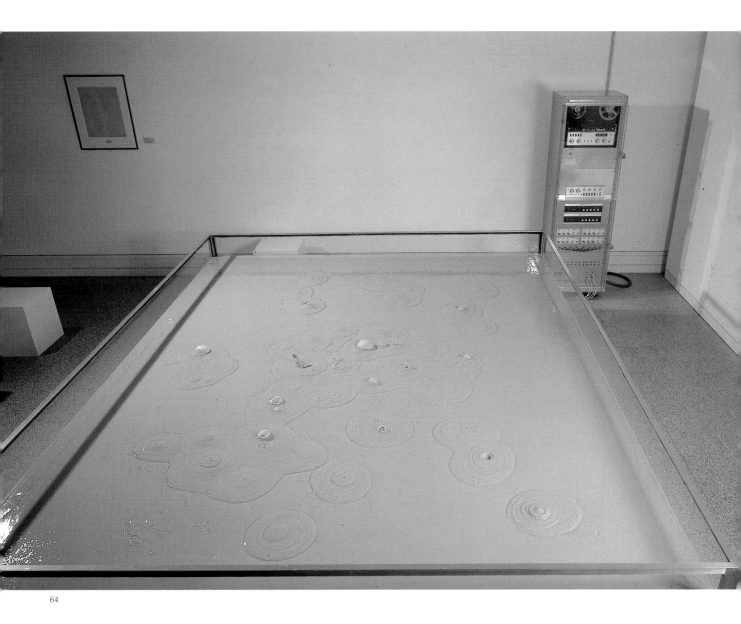

64

64.
Mud-Muse, 1968–71.
Bentonite mixed with water
in aluminum-and-glass vat,
with sound-activated
compressed-air system and
control console,
48×108×144 in.
(121.9×274.3×365.8 cm).

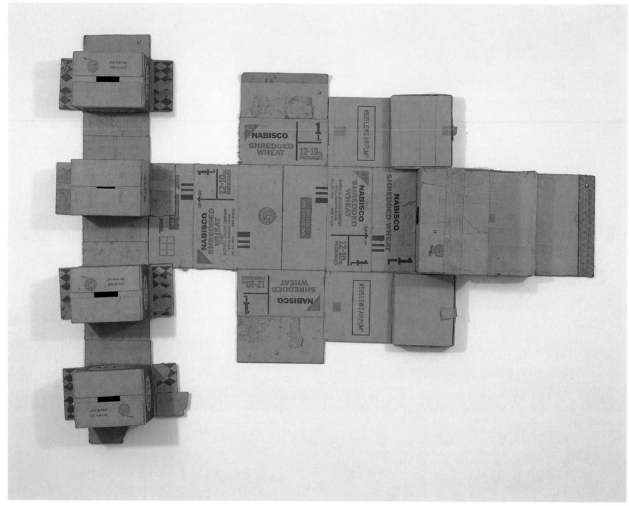

65

65.
*Nabisco Shredded Wheat
(Cardboard)*, 1971.
Cardboard on plywood,
70×95×11 in.
(177.8×241.3×28 cm).

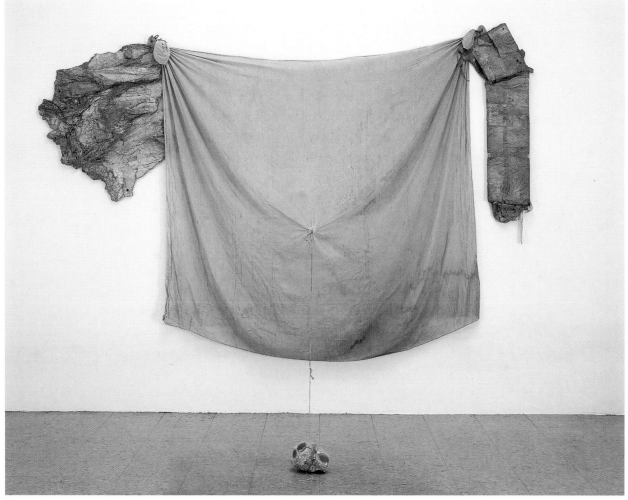

66

66.
Franciscan II (Venetian), 1972.
Fabric, resin-coated
cardboard, tape, string,
and stone,
87×116×47½ in.
(221×294.6×120.7 cm);
installation variable.

Charlene was his final red combine painting of 1954, and like its predecessors, it incorporates found objects, in this case especially those which served as random references to a more general cultural context: postcards, photographs, newspaper clippings, mirrors and even an actual electric light, in effect assimilating its own light source at the core of the art work. The packed, agglutinate and bulging material surface of *Charlene* prefigured the notorious *Bed* painted the following year. That great combine painting brilliantly symbolized his collaborative, acquisitive and voracious energies, and the appetite for assimilations. More than any other work to that date it helped stamp him as the controversial leader of a new, insurgent generation.

The pillow and quilt in Rauschenberg's *Bed* which so shocked the tasteful serve ambiguously both as an abstract expressionist painterly event and a literal derelict object. Incorporating fragments from the domestic world in his paintings, Rauschenberg objectified and depersonalized the Action Painters' "gesture"; he thus managed to keep the dialogue between the sense of art and everyday experience open and unresolved. Short of canvas at the time he made the *Bed*, Rauschenberg simply substituted the pillow, sheet, and patchwork quilt from his own cot. He then hung the work straight up on the wall like a conventional stretched canvas, in contradiction to the bedding's original function, and thereby brought forth one of his first and most provocative assemblages.

The notoriety acquired by Rauschenberg may have been inevitable, since the "junk" materials that he and others established in a new aesthetic context could be read as a symbol of alienation from the dominant folkways of an aggressive consumerist society, a society that extravagantly valued a gleaming, ersatz newness in its possessions. By forcing a confrontation with outcast and despicable object fragments, these artists effectively countered a culture maniacally geared for new, and soon obsolete, products. Their strategies cunningly posed troubling questions about the nature of the art experience and mass culture that gave rise to such blatant violations of the traditional integrity of medium.

Rauschenberg radically deepened the alliance with the image world of popular culture and with the articles of daily life by incorporating Coke bottles, stuffed animals, rubber tires, and miscellaneous deteriorating debris into his work. And against these shocking intrusions, he then forced the painterly qualities and the fluid formal organization of abstract expressionism to operate. Unlike the poetic objects of the surrealists, Rauschenberg's debris was not calculated to shock by its incongruity. Indeed, the artist avoided the associational or fantastic meanings of his "junk art," as it was soon labeled by the critic Lawrence Alloway, and sought to use it in an optimistic, matter-of-fact spirit. Thus, if any social commentary

67.
Sor Aqua (Venetian), 1973.
Wood, metal, rope, glass jug,
and water-filled bathtub,
98×120×41 in.
(248.9×304.8×104.1 cm).

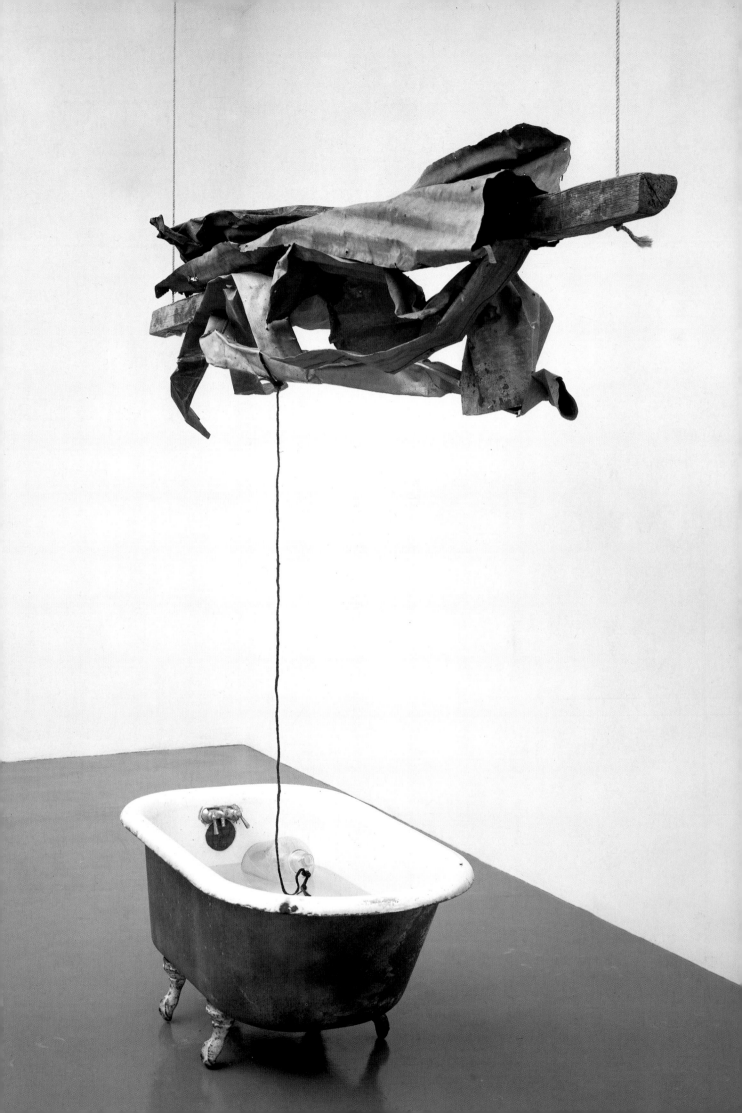

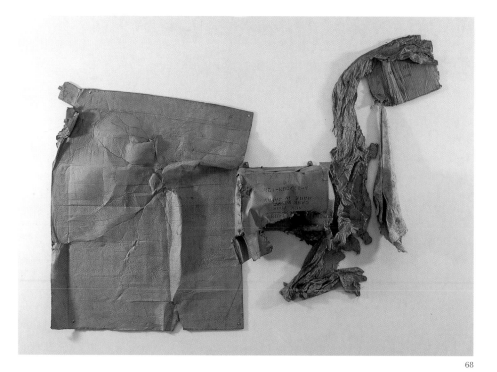

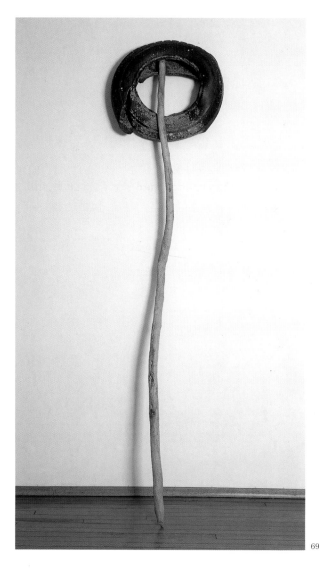

68.
Untitled (Venetian), 1973.
Cardboard and paper on
plywood support with fabric,
64×85$\frac{1}{2}$×12$\frac{1}{2}$ in.
(162.6×217.2×31.8 cm).

69.
Untitled (Venetian), 1973.
Tire and wood pole,
109$\frac{1}{2}$×26$\frac{1}{2}$×19 in.
(278.1×67.3×48.3 cm).

could be read into the content, it was on an elementary and unspecific level, referring primarily to the life cycle of objects in our periodical culture, and their rapid decline into waste as the flow of new goods pushes them aside.

In 1954, his financial situation stabilized when he and his new friend Jasper Johns began dressing display windows for Tiffany and Bonwit Teller. Rauschenberg had moved to a new studio on Pearl Street and Johns, also a Southerner, became his neighbor. The two became inseparable soon afterward; many of Rauschenberg's most striking photographs of the period are candid shots of Johns in his studio, and the two artists visibly influenced each other's work. That spring Rauschenberg showed his combines in the Stable Gallery's "Fourth Annual Exhibition of Painting and Sculpture," among them *Short Circuit*, a clever collaboration with three artists otherwise not in the show: it incorporated paintings by Weil and Johns and a collage by Ray Johnson. He also designed costumes for two of Paul Taylor's dance performances.

By this time, Rauschenberg was no longer a minor vanguard artist, working in isolation and obscurity in his downtown studio. His works had been repeatedly shown and elicited a storm of reaction comparable to the early criticism of The New York School. Commentary ranged from charges that the paintings "were beyond the artistic pale"[38] to more sympathetic remarks like those of Dore Ashton, who wrote that he "speaks of the nature of nature: Cloaked mystery and deterioration. Beauty is purity, he says, but decay is implicit. Appliquéd newspaper is his disdain of perpetuity. Life is cheap. Yes, these black and white canvases excite, incite, make vacuums in walls."[39] It was, however, the red paintings that turned the corner for him; works like the rowdy *Charlene* summed up his vocabulary, paving the way for monumental achievements that soon followed. To many, Rauschenberg's forays into reflected light, earth art and raucous red paintings that barely stayed on the wall were bizarre, silly; to nascent forces in a rapidly changing art world like Ileana Sonnabend, wife of Leo Castelli, his dirt works were "very beautiful, even poetic."[40]

Forever on the move, collaborating on every level, Rauschenberg had by 1955 established the methodology and philosophy that he would mine for the next four decades. The first combine, *Bed*, led between 1955 and 1959 to over 60 combines, chief among them *Monogram* of 1955–59, *Untitled* of 1955, *Odalisk* of 1955–58 and *Coca-Cola Plan* of 1958. Each work combines painting, collage and assemblages of a random glut of objects, disparate and singularly eye-catching. They rank with Schwitters's *Merzbild* and Duchamp's ready-mades in their innovative and subliminal qualities; abstracted from the wider world, created with a quick brush, ever-moving eye and deft hand, they are the essence of the vernacular glance, accretions from a frenetic world. The artist plucked his materials from any source,

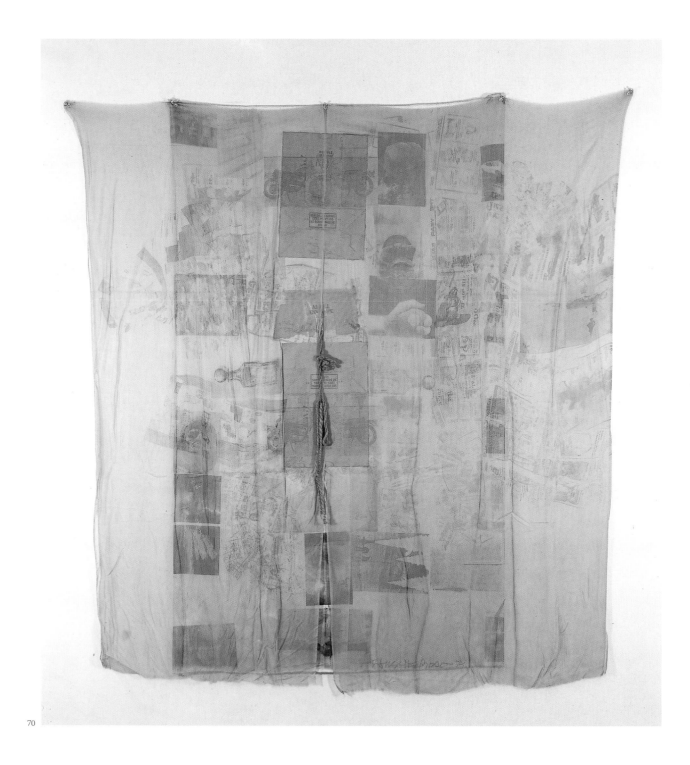

70

70.
Sybil (Hoarfrost), 1974.
Solvent transfer on silk and
chiffon, with paper bags and
rope, 80×74³/₄ in.
(203.2×189.9 cm).

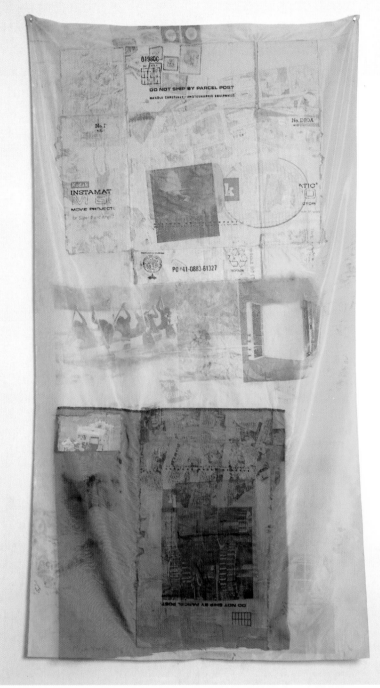

71

71.
Sulphur Bank (Hoarfrost), 1974.
Solvent transfer on satin,
chiffon, and cardboard,
65×35 in. (165.1×88.9 cm).

from family album to curbside and gutter, and tossed them onto canvas, in the form of column and cubic constructions as well as flatbeds. They can be seen from any angle, sideways, upside down; the combines are also extremely personal, even autobiographical.

In them, Rauschenberg presents his family, and himself, works of art by his friends, in his keynote slapdash fashion, linked with dripping, scribbled brushwork. In *Untitled*, a combine on wheels that is part shelter, part porch, part folded painting, he includes a wealth of information, disjunctive and uninterpreted. Snapshots of his bathing-beauty mother, the little Port Arthur house, a twenties-era dandy are displayed on the ramshackle structure, building a haunting impression of an ambivalent mood of nostalgia and regret. Emptiness and loneliness, vacant shoes and past beauty extend to the image of an American flag and a slender young man, the reticent Jasper Johns.

Johns had come to New York from South Carolina, and from the time he and Rauschenberg met, they shared an obsession with an individualistic approach to art, initially with the painting's surface as "flatbed picture plane" that would bridge the gulf between abstraction, then of course supreme, and representation.[41] If Rauschenberg bridged the gap between art and life, Johns mined the rich ambiguities and intellectual resonance of that no man's land between image and idea, concept and representation. Johns made far-reaching innovations in contemporary art with his early painting series of flags and targets, first exhibited in 1957, and the subsequent maps, numbers, rule and circle devices, and other motifs. Together they created radical new forms and options of representation for American art by questioning past assumptions about art.

For five years the artists would share their lives and work, often with an older couple, Cage and Cunningham, as Johns explored the notion of the painting itself as object and his friend worked to erase the line dividing art from life. Their relationship was mutually sustaining and intensely collaborative. Each gave the other "permission to do what we wanted," Rauschenberg has said. "It would be hard to imagine my work at that time without his encouragement."

Cage defined their friendship: "We called Bob and Jasper 'the Southern Renaissance.' Bob was outgoing and ebullient, whereas Jasper was quiet and reflective. Each seemed to pick up where the other left off. The four-way exchanges were quite marvellous. It was the CLIMATE of being together that would suggest work to be done for each of us. Each had absolute confidence in our work, each had agreement with the other."[42] Within that synergistic, nurturing climate, each pushed the limits that constrained him, and his work. Even as Rauschenberg's combines expanded into viewers' space and his involvement in interdisciplinary

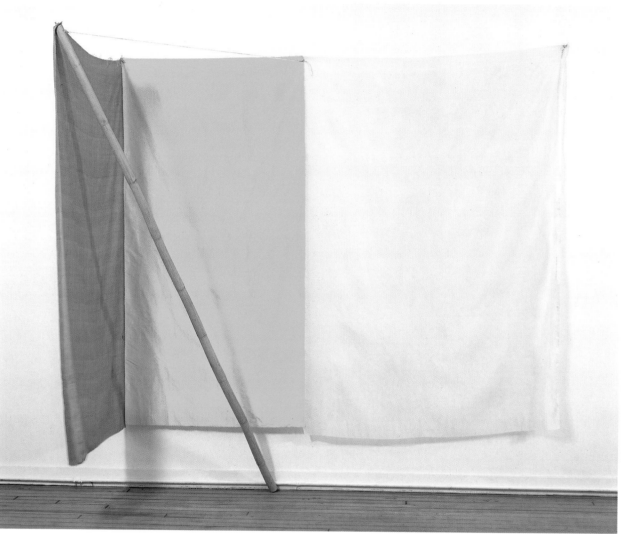

72

72.
Pilot (Jammer), 1976.
Sewn silk, rattan pole,
and string, 81×85×39 in.
(205.7×215.9×99.1 cm).

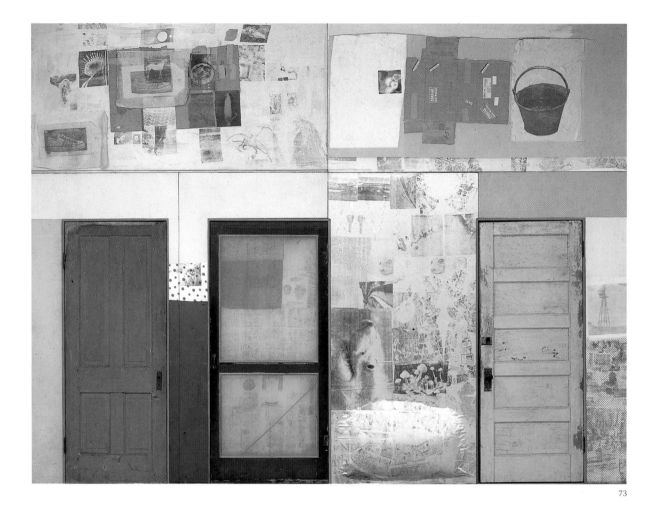

73

73.
Rodeo Palace (Spread),
1975–76.
Solvent transfer, pencil, and
ink on fabric and cardboard,
with wood doors, fabric,
metal, rope, and pillow,
mounted on foam core and
redwood supports,
144×192×5¹/₂ in.
(depth variable)
(365.8×487.6×14 cm).

74.
Coin (Jammer), 1976.
Sewn fabric with objects,
89×43×19 in.
(226.1×109.2×48.3 cm).

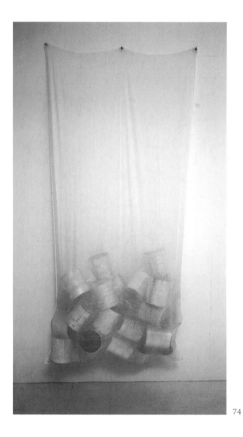

74

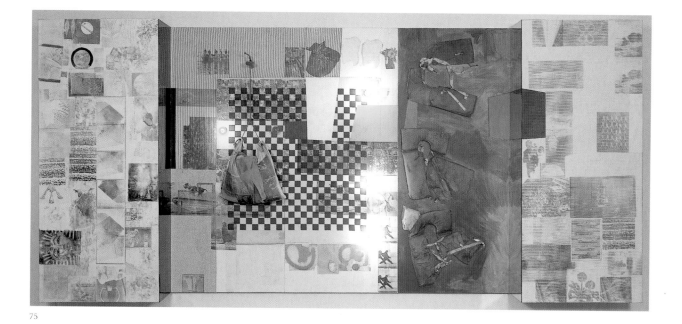

75

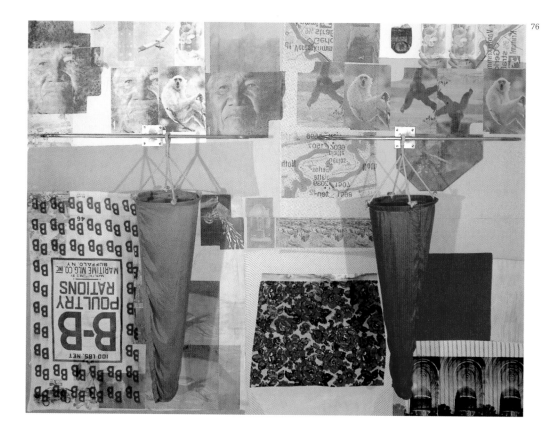

76

75.
*Corinthian Covet
(Spread)*, 1980.
Solvent transfer and
collage on plywood
panels with objects,
84×185×19 in.
(213.3×469.9×48.3 cm).

76.
Tattoo (Spread), 1980.
Solvent transfer, acrylic,
paper, and fabric, with
wind socks and metal
fixtures, on wood,
73³/₄×96⁵/₈×19 in.
(187.3×245.4×48.3 cm).

performances grew, he explored the central precept of abstract expressionism.

In *Factum I* and the identical *Factum II*, both of 1957, he threw into question the notion of spontaneity. Their corollaries, his *Summer Rental 1 + 2* of 1960, confront the notion of artistic inevitabilty; the works are composed of the same elements, but are quite different. They may seem to be amusing exercises but are far more, for the artist poses serious questions about art and life, and provides enlightening answers. If they are also knowingly rather entertaining, that does not detract from their significance. Indeed, it only increases their complexity.

More controversial was the work that Rauschenberg began in 1955, when he brought home a dingy stuffed Angora goat and tried to clean it up. He shampooed its long fur, then daubed paint onto its damaged nose and placed a tire around its midriff. Rauschenberg then struggled to make it part of a combine. It didn't work as part of a painting, nor did it work in front of a painting; he finally, with help from Johns, set it on a painted platform, its private pasture. What gave *Monogram* its excitement was largely external: Robert Hughes has noted that Rauschenberg, like Duchamp, embedded "a kind of ironic lechery in his images . . . it is [his] monogram, the sign by which he is best known—but why did it become so famous? Partly because of its unacknowledged life as a powerful sexual fetish. The lust of the goat, as William Blake remarked, is the bounty of God, and 'Monogram' is an image of copulation."[43]

Also imbued with sexuality, subliminal or not, were works that toyed with ideas of rape and the eroticism of Ingres' harem girls, *Bed* and *Odalisk*, adorned with a chicken that shocks and amuses by bringing to mind notions of cocks and "*poules de luxe.*" By 1959, when Rauschenberg brought his more serious interests to the forefront with 34 illustrations for Dante's *Inferno*, he had begun to grow beyond his role as *enfant terrible*. Leo Castelli and Ileana Sonnabend (then his wife) had visited Rauschenberg's studio in the spring of 1957, eager to see new art for the gallery they'd opened for emerging artists. Rauschenberg showed his work, then he took the dealers to see works by Johns.

The reaction was positive, immediate and even overwhelming. The couple scheduled Johns for an exhibition the following January, turning his public debut into a sensation when his show sold out and made the cover of one of the two leading art world publications, *ARTnews*. Rauschenberg's show in the spring of 1958 was a *succès de scandale*. Johns had emerged as a major force, and within a few years the two would find their friendship transformed into a rivalry. Rauschenberg was later to recall how different the two artists were, yet how engaged they were as a unit, emotionally: "It was my sensual excessiveness that jarred him.

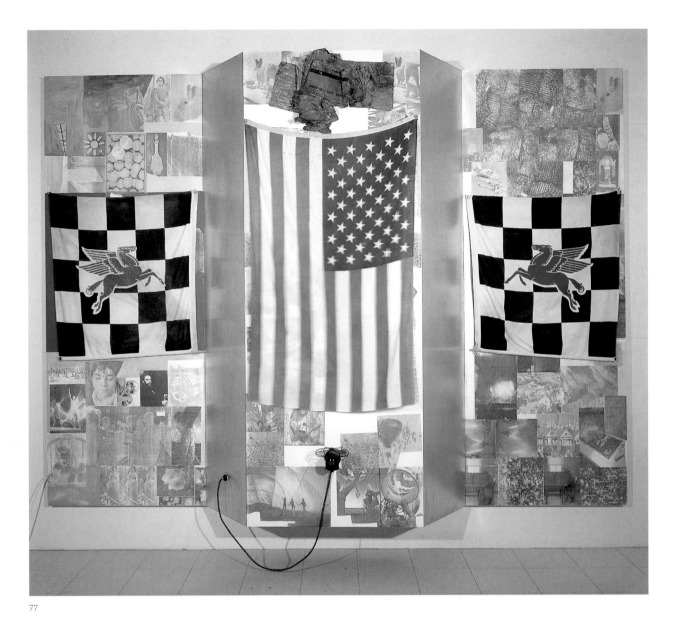

77

77.
Pegasus' First Visit to America in the Shade of the Flatiron Building (Kabal American Zephyr), 1982.
Solvent transfer, acrylic, and collage on plywood and aluminum with objects, 96^1/$_2$×133^1/$_2$×22^1/$_2$ in. (245.1×339.1×57.2 cm).

78

79

78.
*Untitled (Kabal American
Zephyr)*, 1983.
Assembled construction,
73×20×24 in.
(185.4×50.8×61 cm).

79.
Fish Park (ROCI Japan), 1984.
Acrylic and fabric collage on
canvas, 78¹/₂×220¹/₄ in.
(199.4×559.4 cm).

80.
*Guarded Mirror Rivers (ROCI
Venezuela)*, 1985.
Acrylic and fabric on plywood,
49¹/₂×98⁵/₈ in. (125.7×250.2 cm).

He was always an intellectual. He read a lot, he wrote poetry—he would read Hart Crane's poems to me, which I loved but didn't have the patience to read myself—and he was often critical of things like my grammar. But you don't let a thing like that bother you if you have only two or three real friends."[44]

Though the Castellis's enthusiasm might have been disruptive for Johns's work, their unstinting support was of inestimable value to both artists. Leo admired Rauschenberg's "amazing natural intelligence, broad range of knowledge, and openness to new experience"; Ileana, who would soon open her own influential gallery in Paris, saw in Rauschenberg a "strange mixture of boastfulness and humility, depression and high spirits . . . a spiritual quality . . . as well as a poetic and ephemeral quality."[45]

Even as his combines received international attention, Rauschenberg was experimenting with techniques taking him back to a more traditional, flat painted surface. This development first emerged in his delicately shaded and hatched drawings, where he experimented with a technique of "rubbings," to transfer photographic images onto another sheet of paper, instead of attaching the actual photograhs to the surface of a work, as he had been doing. He soon began to use photographic images even more freely, and in larger scale, to make photo-silkscreens and then transfer them onto his canvases with both commercial inks and oil paints.

Rauschenberg's technical method required soaking selected areas of a sheet of paper with lighter fluid and then placing a photographic image from a magazine or newspaper face down on the wet paper and rubbing the back with the nib of a dry ball-point pen. The image was thus transferred to the paper, with a grayed and somewhat ghostly quality, yet retaining its identity as a photographic reproduction. Rauschenberg then mediated the mechanical image registration with considerable creative freedom, by brushwork, linear invention, and color application. Rauschenberg's first major drawing series, the dramatic thirty-four drawings corresponding to the Cantos of the Inferno of Dante's *Divine Comedy*, depended on this method; the drawings were done in 1958–60.

It took him 18 months to finish the project, updating his imagery to his own time as he withdrew to a Florida fishing village, near Saint Petersburg. When the Cantos were shown at the Castelli Gallery in 1960, the year he met Duchamp, they won widespread critical acclaim that overshadowed the reaction to his inclusion in 1959 in the Museum of Modern Art's "Sixteen Americans" and other group exhibitions. Not only did he win positive attention from critics, he also won a $3,000 award for the 1959 combine *Inlet* in 1960 at the Art Institute of Chicago's "Society for Contemporary American Art Annual Exhibition XX and 20th Anniversary Exhibit."

81

82

81.
Shade (Salvage), 1984.
Acrylic on canvas,
81 1/4×97 3/4 in.
(216.4×248.3 cm).

82.
Dancing Cliche (Shiner), 1986.
Acrylic and objects on
stainless steel sheet with
aluminum frame,
48 3/4×60 3/4 in.
(123.8×154.3 cm).

83

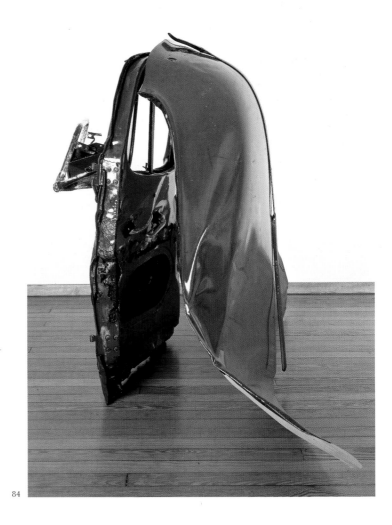

83.
Rudder Glut, 1986.
Assembled construction,
26×37×11 in.
(66×94×27.9 cm).

84.
Carnival Glut, 1986.
Construction, 50×73×43 in.
(127×185.5×109 cm).

85.
Read Lead Glut, 1986.
Riveted metal parts,
76×96³⁄₄×39¹⁄₂ in.
(193×245.7×100.3 cm).

86.
Flaghole Glut, 1987.
Construction of found
aluminum and metal objects,
32×100×59 in.
(81×254×150 cm).

84

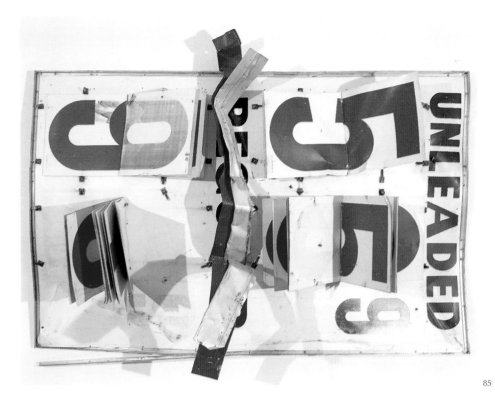

85

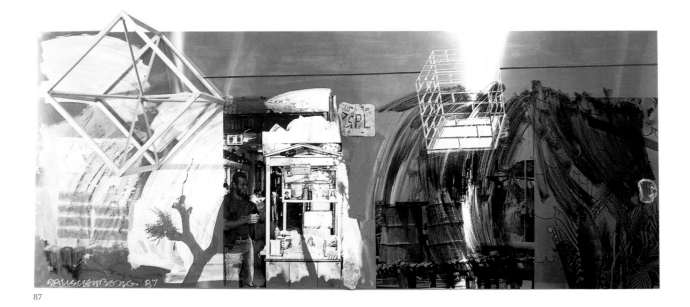

87

88

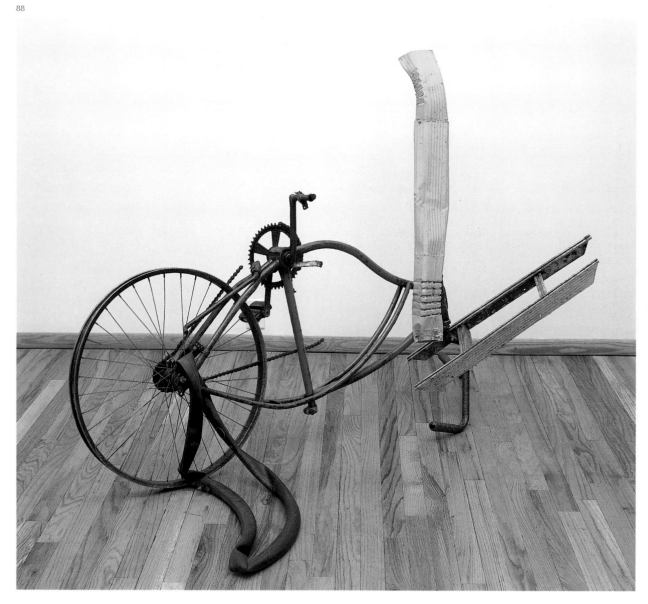

98

89

90

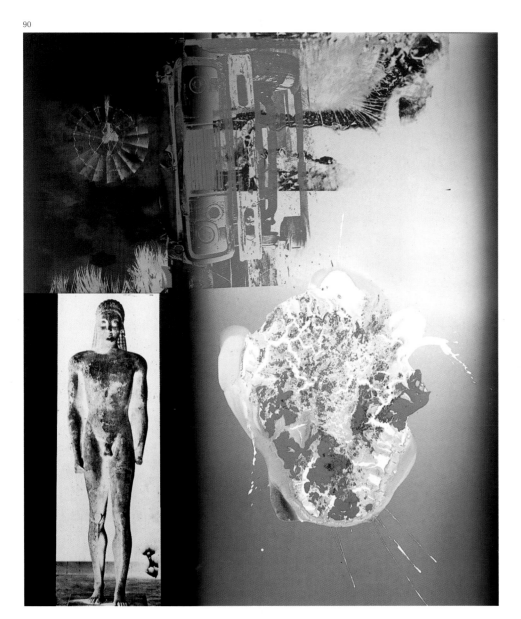

87.
Ballast (Shiner), 1987.
Acrylic and objects on
stainless steel,
48³/₄×120⁷/₈×20 in.
(123.8×307×50.8 cm).

88.
Primary Mobiloid Glut,
1988.
Assembled construction,
44×67×27 in. (variable)
(112×170×69 cm).

89.
Snow Gate Winter Glut,
1987.
Assembled metal parts,
24×130¹/₂×16 in.
(61×331.5×40.6 cm).

90.
*Greek Yearn (Urban
Bourbon)*, 1988.
Enamel and acrylic on
anodized aluminum,
84³/₄×72³/₄ in.
(215×185 cm).

Meanwhile, his paintings, ever larger, more vibrant and more aggressive, had expanded tremendously. In 1962, he shifted ground and felt again the need to paint flat; collages were showing up in galleries, and he decided to move in a new direction. The evident limitations of the transfer technique, since the photograph can be used only once and has to appear in its original published size, could be accomodated in drawing but posed obvious problems for larger paintings. Probably influenced by Warhol, Rauschenberg began using photo-silkscreens made from published photographs. Gradually these images of persons, events, accidents and disasters in the world replaced the attached objects and materials of the combines and became the exclusive narrative and iconic substance of Rauschenberg's work.

He explained his motives in making the change: "I was bombarded with TV sets and magazines, by the excess of the world," said Rauschenberg, for whom a constantly flickering, silent or almost inaudibly murmuring television screen is a given of his domestic and studio environments. "I thought an honest work should incorporate all of these elements, which were and are a reality."[46] The medium's effects were similar to those he had devised for the Cantos, and allowed him to bring in images from his own photographs and widespread commercial sources, at any size.

His immense, 32-foot-long painting, *Barge*, of 1962–63, was one of his most ambitious and explosive works; its cluster of images reflect the "extremely random order that cannot be described as accidental,"[47] the actual impact of life as he perceived and transmitted it. As his style and deft manipulations of screen imagery evolved, Rauschenberg utilized more and more imagery taken directly from current photojournalism, which in the sixties had begun to transform the shape and contents of the art experience radically. New spatial and communication ideas infiltrated art through the process-oriented media of picture magazines, films, television, exhibitions, and other events that opened up unexpected creative opportunities and changed the forms of traditional painting. Rauschenberg was perhaps the first artist to test the new technical and esthetic frontiers, now so famliar, in response to the communications dynamism of the electronic age.

Exhilarated by the freedom he found in silkscreening, he agreed that summer to work with Tatyana Grosman at her Universal Limited Art Editions studio in West Islip, New York, in a different print medium that was quite new to him, lithography. Ms. Grosman's print establishment was to become the pioneer in the great American print revival, and ultimately the most celebrated and artistically demanding which the foremost contemporary artists eagerly patronized. Once again, Rauschenberg had found a new medium to which he was peculiarly suited in ways he could not have predicted; the textures, multiplicity, flexibility and reversibility of the

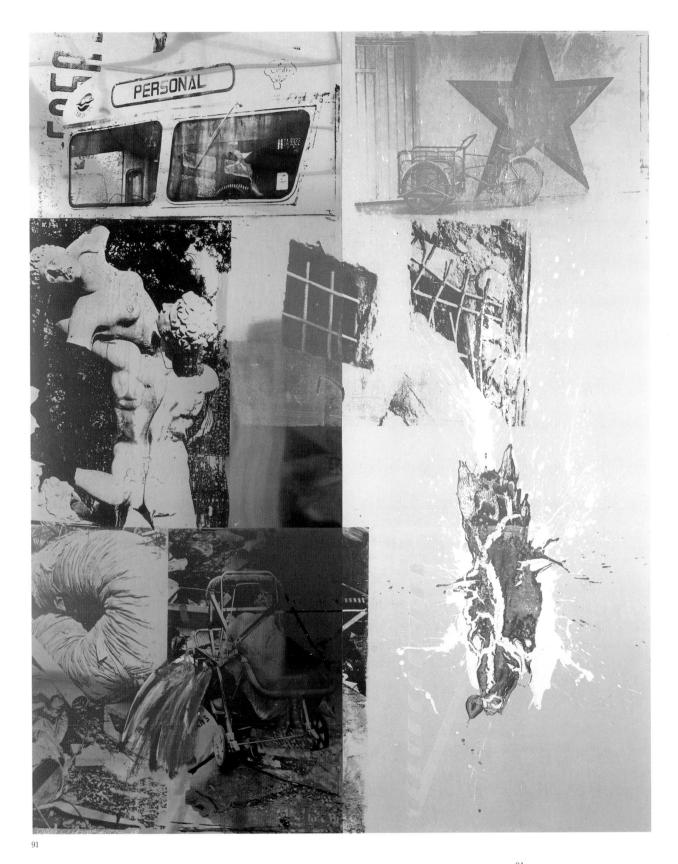

91

91.
Favor-Rites (Urban Bourbon),
1988.
Acrylic on mirrored and
enameled aluminum,
$120\,^{3}/_{4} \times 96\,^{3}/_{4}$ in.
(307×246 cm).

images he made, prolifically, in Grosman's initially rather ad hoc Long Island studio delighted him. Even occasional accidents became part of the work, as artist, stone and technicians collaborated on a previously impossible scale that made the process even more exciting, and surprising. "With Rauschenberg to work is something heroic," Grosman would recall. "There is always a conquest, a subduing of something unexpected. Always some new discovery."[48]

In the spring of 1963, with his involvement in performance art continuing and printmaking accelerating, he followed a successful series of international exhibits with a major one-man show, at the Jewish Museum. The retrospective was organized by Alan Solomon, who had introduced avant-garde art to the modernized and newly expanded Manhattan museum. The show was very unusual for such a young and controversial artist; Rauschenberg, at 37, had been gaining ground critically, but still was not regarded as an artist worthy of a serious museum retrospective. The 55 works (with the 34 Cantos from Dante's *Inferno* listed as a single piece) shown at the Jewish Museum, however, earned him much critical acclaim from unexpected quarters: *The New York Times* called him "one of the most fascinating artists around." Max Kozloff, a leading younger critic, hailed his art as "the most significant being produced in the United States by anyone of the younger generation."[49] The opening itself, the first of the decade's gala art outpourings for an artist of the post-De Kooning generation, was a sensation.

Rauschenberg's reputation caught fire that year and the next after a flurry of international exhibitions, and much favorable media attention. He seemed to be setting the pace in an affluent and reenergized contemporary art world with multiple "hot" styles. Soon after the Jewish Museum show his 1961 combine, *First Landing Jump*, entered the Museum of Modern Art collection. In 1964 he traveled to Europe and Asia with Cunningham's company and had solo shows in Turin, Paris, Germany and, most notably, at the Whitechapel Gallery in London, as well as various American commercial venues. The response to his work was strong and now unfailingly laudatory: his London show was called "the most exhilarating art exhibition . . . the most influential and enjoyable show of the year."[50]

Just four months later, while he was touring with Cunningham on the well-received tour, Rauschenberg's position in the international avant-garde and its art world support system reached an apogee when he won the Grand Prize at the Venice Biennale, the third American artist to do so, after James Abbott McNeil Whistler and Mark Tobey. It was a high honor, indeed, albeit received in an atmosphere of unusual divisiveness over the prize, with considerable recriminations. Only one of his 22 pieces selected by the American Commissioner, Alan Solomon, was actually hung in the

92

93

92.
Sleeping Sweeper (Urban Bourbon), 1988.
Acrylic and enamel on mirrored anodized aluminum,
96³/₄×120³/₄ in.
(246×307 cm).

93.
Novel Quote (Urban Bourbon), 1988.
Acrylic on enameled aluminum, 120³/₄×96³/₄ in.
(306.7×246 cm).

94.

94.
Courtyard (Urban Bourbon),
1989.
Acrylic and enamel on
enameled aluminum,
121×144³/₄ in.
(307.4×367.7 cm).

small official United States pavilion on the grounds of the public gardens with the other national representations; Solomon had arranged for the rest to hang in the U.S. Consulate, with the permission of the Biennale authorities. Controversy erupted over whether those works could be legitimately considered for the prize, and only at the last moment did the seven judges reach agreement and vote him the preeminent grand prize.

Needless to say, the customary Biennale atmsophere of connivance and politicking helped make the decision controversial. Nonetheless, the choice of Rauschenberg was much acclaimed by the younger generation in the United States and abroad for whom he had become a liberating symbol, despite expressions of outrage in the European press which viewed the decision as a symbol of America's bullying power in the context of the Cold War. In Paris the left-wing journal *Combat* called the award "an affront to the dignity of artistic creation." At the other political extreme the Vatican's *L'Osservatore Romano* viewed it as "the total and general defeat of culture."[51] Despite these extreme responses, after years of having even serious art people (including other artists) dismiss his work as a joke or an abberation, Rauschenberg had finally begun to impress the influential tastemakers.

Rauschenberg was overwhelmed when he learned that he would take home a prize worth $3,200, and somewhat taken aback. As his tour whith Cunningham continued, he was besieged with attention. He res-ponded perhaps typically: in a grandiose statement, misinterpreted by his dance-and-music partners as a self-centered put-down diminishing their own rather more important creative roles in the ensemble, he said "the Merce Cunningham Dance Company is my biggest canvas."[52] The offhanded remark led to hard feelings and a split between Rauschenberg and his most valued friends, including Cage and Johns as well as Cunningham. He also broke off, in a sense, with his artistic past. Before returning to New York, he contacted a friend and asked him to destroy all of his incomplete projects, mostly silkscreens; his major works were now selling at prices between $10,000 and $50,000, but Rauschenberg wanted to assure himself that he would not be tempted to trip over his own visual cliches.

Instead, he broke new ground in his combines, as he arranged to move to larger quarters. In 1965, he bought an abandoned orphanage on Lafayette Street near the East Village and began renovations on the huge, drafty building which included a four-story-high chapel. He collaborated with a variety of creative individuals, among them artists Jean Tinguely and Niki de Saint-Phalle, poet Kenneth Koch and the Judson Dance Theater (some of them Cunningham dancers), with whom he performed on roller skates in the famous *Pelican* number. Rauschenberg felt strongly that he had to protect himself in the face of such enormous changes, which

might lead to pressure to conform in the glare of public life. "It's as though I've slipped into the wrong skin," he said at the time, "which is a little bit scary. I mean, if your work is more or less all you're doing, you could get to feel sort of isolated.

"I'm starting to get this sense of, well, how difficult is it going to be to stay in touch? And I can't afford to lose touch with myself. Because that's really all I've got."[53]

As his interdisciplinary and multi-media collaborative efforts expanded, Rauschenberg's restless nature became ever more evident. "I am sick of talking about What and Why I am doing. I have always believed that the WORK is the word. Action is seen less clearly through reason. There are no shortcuts to directness."[54] With his friend, the innovative Bell Lab engineer Billy Kluver, he founded Experiments in Art and Technology (E.A.T.) in November 1966; their efforts stemmed from the same urge that resulted in his theater pieces, melding their two areas of expertise in works whose concepts often seemed more interesting than the pieces themselves. Reaching into novel realms, Rauschenberg produced mixed-media pieces like *Oracle*, the construction that converted his layered combines into free-standing sculptures, the immense neon *Green Shirt* and *Soundings*, an elegant, subtly modulated silkscreen-and-Plexiglas assemblage construction in which electronics play a key role. Some critics felt Rauschenberg was overreaching both in scale and his flirtation with interactive technology, and in the utilization of different senses: "No matter how loud you shout or how low you whisper at *Soundings*, you still see the same old static chairs," *New York Times* critic Grace Glueck wrote unsympathetically. "That's 'participating in the 'creation' of a work?"[55] In retrospect, the works of this period now seem prophetic of the ambitious installation and performance art of the nineties, and relatively conventional in comparison with their alternatively subjective emphasis and obsessive concern with social issues.

By the time E.A.T. dissolved, in 1970, Rauschenberg again had shifted gears. His printmaking had expanded in 1967, when he began working with Gemini G.E.L., the Los Angeles printing and publishing firm which produced the Booster and 7 Studies; he was also still active in performances and even television segments. He showed his new work internationally, not repeating himself but at the same time not breaking dramatic new ground with serious exhibits at the Castelli Gallery and the Museum of Modern Art, among many others. His interest in technology did not end with the demise of E.A.T., as he collaborated in new crossover pieces and expressed delight in the American outer space program, celebrating the expoits of astronauts and space shots in constructions and large-scale prints. He also involved himself on a more personal level in social issues

95

96

95.
Grand Slam (Galvanic Suite),
1990.
Acrylic and enamel on
mirrored aluminum and
galvanizad steel, 4 panels,
121¹/₄×193¹/₂ in.
(308×491.5 cm).

96.
A Doodle (Borealis), 1990.
Acrylic and tarnishes
on brass, 72³/₄×96³/₄ in.
(184.8×245.8 cm).

97

97.
Orrery (Borealis), 1990.
Acrylic and tarnishes on
brass with brass objects,
97×181×23 in.
(246×460×58.5 cm).

98.
Cradle Tilt (Borealis), 1991.
Acrylic and tarnishes on
brass, 91×36 ⁷/₈ in.
(231.1×93.7 cm).

through his charitable foundation, Change, Inc., a program of grants up to the sum of one thousand dollars for younger artists in need of financial asistance.

But the art scene itself was changing, from the turbulent but sociable early sixties, when Rauschenberg's generation made common cause creatively and flourished despite the ongoing Cold War and the increasingly preoccupying Vietnam quagmire. Soon, however, festive drug use became overdoses; high spirited, innocently rebellious music turned into hard or even acid rock; Vietnam tore at the national fabric; a crazed, extremist fan shot and nearly killed Andy Warhol, and Janis Joplin, Rauschenberg's fellow Port Arthurian, became a fatal casualty of the drug culture. The times themselves had become a bummer, and Rauschenberg sought refuge and solace in the remembered warmth and consolation of a lost innocence. His art-making faltered and stagnated despite his international celebrity, as he began to lean too heavily on Jack Daniels, his beverage of choice, and a doting entourage. Overwrought and overcome by fits of Baudelairean spleen and ennui in the midst of a no longer sustaining metropolis, he looked for succor and answers elsewhere. "I was beginning to feel that so many of my friends . . . were having so many problems that perhaps I was responsible for some sort of evil spirit," he said in the late sixites.

"I got so depressed that I went to an astrologer. . . . everybody I knew was breaking up. Everything was falling apart. There was such an abundance of bad news. . . ."[56] He finally sought respite from his New York funk where he had found refuge a decade earlier, when he began to slip away periodically to work in seclusion in Florida, across the Gulf from Texas. When he first came to Captiva, in 1962, it had been a six-mile sliver of sand and tough native vegetation, wild and isolated from the mainland. It gradually had been developed, as a causeway linked it to land, but remained a refuge; in 1971, Rauschenberg finished his New York series, Currents, and, driven by a desire to evade "world problems, local atrocities and in some rare instances . . . men's accomplishments,"[57] all the forces he had in the past absorbed with emotional detachment, if not indifference, in his work, he beat a retreat to Captiva, encouraged to seek spiritual refreshment there by an astrologer.

There he poured his energies into new work, first setting up a studio adjoining his own house and, next, a print studio on the other side of a palmetto jungle. He named his lithographic press Little Janis, after the late singer, and an outpouring of work by Untitled Press began, in collaboration with Twombly and others. He also began new combines on a larger scale, using available materials from the immediate environment, as in the past, but perhaps redistributing them more economically. In Captiva, there was no urban or highway glut to draw on, however. Cardboards, the series that

99

99.
Rudy's Time (Night Shades),
1991.
Tarnishes on brushed
aluminum, 85×97 in.
(216×246.5 cm).

100

began to emerge in those early Florida years, drew on the boxes he salvaged, complete with staples, tears, stamps and other random evidence of their previous existences. He wanted to use "a material of waste and softness," Rauschenberg said of works like *Nabisco Shredded Wheat*. Because for five years he had focused on social causes, he welcomed "something yielding with its only message a collection of lines imprinted like a friendly joke."[58]

Some saw his 1971 exhibition of the restrained, rather minimal Cardboards, handsomely installed at Leo Castelli's spacious new downtown gallery space at 420 West Broadway, as a comeback; Rauschenberg found the idea of his having ever been away annoying. Nonetheless, most reaction to the work was positive. The totemic Cardboards, like their *trompe l'œil* knockoffs, the Cardbirds, and the series that followed as he worked in sites that sparked his creativity drew directly from their surroundings, expressing in the simplest, most intuitive way possible their own ambiance. Florida, and other more exotic venues, Venice, France, the Middle East, India and Florida again—all came through in work that unrolled like the scroll of time itself: veils of fabric, elegant, shimmering, translucent Hoarfrosts printed on unstretched gauze, quirky Venetian combines redolent with "rotting grandeur"[59] of the great Adriatic port, like *Sor Aqua* of 1973, Pages and Fuses molded from handmade paper, Egyptian pieces that incorporate sand, Scriptures and Pyramids of paper, Bones, sublime in their elegant purity, and the lyrical fabric Jammers.

In those varied, highly poetic works of the seventies, Rauschenberg not only took from the world around him, he also transformed his materials with the magical skills of an alchemist. Taking the chilly wood pulp of the Massif Centrale or sand from the desert, or herbs and mud, he turned them into artist's gold: art that appears effortless and inevitable. There was a new expansiveness, evident material pleasure and a soaring freedom in the works that came after the move to Captiva, as if the light, air, sea and sun had liberated an imprisoned soul. It was a momentarily despairing soul and an overwrought sensibility that had reached a state of sensory overload. By the mid-seventies, he began to see the world differently. "For the first time, I wasn't embarrassed by the look of beauty, of elegance," he said after a trip to India, a major port of call in his global peregrinations which had resumed.

"Because when you see someone who has only one rag as their property, but it happens to be beautiful and pink and silk, beauty doesn't have to be separated." In India, Rauschenberg has said, he no longer shied away from "something being beautiful. I've always said that you shouldn't have biases, you shouldn't have prejudices. But before that I'd never been able to use purple, because it was too beautiful."[60] India, with its marvelous colors and textures, was a revelation; after his return, the subdued Hoarfrosts became more vivid, and the loose, waving Jammers appeared. Their titles—*Reef, Pilot, Coin*—hint at marine sources without capturing their sheer voluptuousness. As the seventies ended, however, he turned back to a seminal Dadaist work, *Automobile Tire Print* of 1951, and reprised

101.
Tabernacle Fuss
(Urban Bourbon), 1992.
Acrylic on enameled
aluminum, 121×241 in.
(307.3×612.1 cm).

113

102.
Intersection (Night Shade),
1991.
Acrylic and tarnishes on
brushed aluminum, 85×49 in.
(215.9×124.5 cm).

102

114

it in three dimensions. *Tracks* is, and is not, the same; Rauschenberg had turned another corner, and his work exploded again in size, scale, color and imagery of an unprecedented richness and variety.

The magisterial Spreads series express forcefully the work that began with America's bicentennial celebration, as Rauschenberg was chosen to be "the nation's greatest living artist" and, on a more personal level, lived out his 50th year. An ambitious retrospective exhibition was mounted at the Smithsonian Institution's National Collection of Fine Arts, representing 157 works dating from 1951 to 1976, including his newest *Rodeo Palace (Spreads)*, an ambitious combine that brought together elements from all of his previous work, and could be seen as a kind of summation. Originally created for an exhibition in Texas devoted to the American rodeo, it combined some of the synoptic, flashing juxtapositions of his silkscreened imagery of the sixties with collage techniques and material contrast preserved from his earliest work.

It was also the jumping-off point for new, more expansive types of Spreads—most notably the complex *Corinthian Covet*—and whole series that emerged, one after the other or in overlapping sequences: the mystical Kabal American Zephyr, Shiner, Salvage, Gluts, Urban Bourbon, Galvanic Suite, Borealis, Wax Fire Works, Night Shade and finally, in 1994–95, the stupendous Quake in Paradise, an optically vibrant but organic labyrinth in environmental scale. One of his most ambitious recent works, it is constructed on an armature of transparent Plexiglass panels decorated with silkscreen photographs and brightly colored puddles of paint. Enhancing the effect of teeming multiplicity are the mirrored surfaces which redouble and distort the reflections of the facing mirrors, enhancing the effect of architectural scale.

But from the early eighties, it was ROCI that absorbed much of his time, energy, talent and, not incidentally as the cultural-exchange program's price tag soared, his financial resources, siphoning off as much as $4 million, much of it from sales of his increasingly rare and valuable work of the fifties and sixties. (At the peak of the overblown art market, in 1989, such landmark combines as his monumental *Rebus*, constructed in 1955, fetched more than $6 million at auction; Rauschenberg's standing in the art market has remained rock-solid ever since.) His fascination with diverse cultures, sources and materials, which became evident on his first trip abroad, in 1952, has grown into a complex artistic program. Its aim, he has said, was to create collaborations in participating countries by "getting to know the culture, working with local painters, writers, poets, and artisans, and achieving familiarity with the character of the region."

ROCI made its debut in 1985, at the Tamayo Museum in Mexico City, with an exhibit of some 250 of his recent works; after that, the constantly evolving project traveled from one participating country to

another, each serving as a sort of ongoing, in-progress art caravansary: China, Chile, Venezuela, Japan, Cuba, Germany and the former U.S.S.R. The project reflected perfectly Rauschenberg's omnivorous appetite for "life and the world," as he put it. First it required peaceful negotiations, verbal collaborations, and then an arrangement among artists and the wider community. Rauschenberg and his team visited numerous countries, many tiny, remote and exotic, and there he actively collaborated with local and regional artists in making artworks that, like his earlier overseas pieces, drew on different countries, traditions, materials, exchanges of ideas, approaches and techniques. Works from the various countries across the globe entered his constantly expanding, itinerant show, which constantly changed and grew "on itself like a mold," as he explained to the author.

Complex though ROCI was, it was simple, too, and easily comprehensible to a general audience with even a rudimentary art sensibility. It is the ultimate expression of his lifelong urge to reach out, work with others, use mundane items—seemingly random *objets trouvés*—taken from his world and reconstructed in combinations that readily communicate to a wide audience. What they say, each to each, matters as much as process to Rauschenberg, although he rejects the notion that works of art embody and convey emotions from artist to viewer; the viewer himself completes the work of art, which is a part of life. Unless life itself is art, in which case it hardly matters how information, impressions, glimpses of reality or not-really-reality are construed, semaphored, absorbed, and perceived. His largest, most complicated and many-tiered concept, ROCI, in an odd but logical manner completes a circle begun long ago, in steamy Port Arthur. With more than a touch of evangelism, it seeks to promote international communication, understanding, peace and friendship through jointly conceived, visual documents created by a mosaic of avant-garde artists sharing beliefs and collaborative technical means.

The impetus for the ROCI program arose from an interdisciplinary collaboration, when he was touring China with Trisha Brown and her dance troupe, as set-and-costume designer. Rauschenberg was struck by how remote the region seemed. "One of the most distressing things I found there," he has said, "was the lack of information about the rest of the world." So he set off on his selective world tour, free from government aid because he wanted to remain as independent and apolitical as possible, on a mission oddly reminiscent of his 1964 tour with Cunningham, Cage, the composer Karlheinz Stockhausen and others.

With its world stage and awesome scale, ROCI cumulatively bears some similarity to the earlier, sprawling *1/4 Mile or 2 Furlong Piece*. His oeuvre, indeed, presents a singular unity over the past half century, and has been based consistently on intuitions and aspirations that have

104.
*A Quake in Paradise
(Labyrinth)*, 1994–95.
Acrylic and graphite on
29 panels of bonded
aluminum, anodized
mirrored aluminum, and
polycarbonate (Lexan) with
aluminum framing.
Variable dimensions and
panel groupings.

104

remained central and steadfast. As one of his best exegetes, Walter Hopps recently wrote with regard to his early work:

"Rauschenberg . . . sees and relishes the simple known facts of things, animate and inanimate. For him, visual poetry involves not just a reverie of introspection but the results of process and direct action—finding, doing, and experiencing. His art is informed with a serious intelligence, an optimistic wit and sense of irony, and an openness 'to let in the world.'

"The late American art historian Joshua Taylor wrote tellingly of Rauschenberg's art, characterizing it as ' . . . freeing the viewer to discover beauty and meaning where he might least expect it . . . ' a beauty that comes from order found, not order given, as if its permanent harmony existed precariously in a transient and unpredictable world."[61]

Rauschenberg's once unimaginable success, given the casualness and radicality of his forms, and their brute material reality, has today given way to acceptance and the assimilation of his plastic inventions into the mainstream of art, with their inevitable conversion into recognizable visual cliches at the hands of imitators. The rumpled, discordant, ambiguous forms that were once shocking in *Bed* have been defanged by cultural assimilation; a recent gift of the Castelli family, the work is now installed harmoniously as the educational bridge between the masters of abstract expressionism and pop art in the galleries of the Museum of Modern Art, in New York. Like the White and Black Paintings, the revolutionary combines, the masterful screen paintings of the sixties and the poetic fancies and material explorations of the seventies, they have been integrated seamlessly into the mainstream of modern art.

Rauschenberg's works of art from every period are the palpable extension of an expansive, mercurial consciousness. Compilations of things—objects, images, colors, non-colors, textures, fleeting thoughts from a vast, splendid, unassimilable cosmos—they sprang into being from his own intense, alert concentration, as he made himself available to external experience and his inward musings. He responded to anything, everything, and even nothingness: "My whole area of art activity has always been addressed to working with other people," he has explained. "You see, I personally like the sensual contact of collaborating. Ideas are not real estate. In collaboration one can accept the fact that someone else can be so sympathetic and in tune with what you're doing that through this they move into depths that might not be obvious if that person had been working alone in a studio with the door shut."[62]

However his work has evolved, keeping itself fresh as he tried to remain a step ahead of critics and imitators, it continues to deliver the recognizably modernist sense of shock. It also remains much the same in concept and substance, a unique mixture of pragmatic receptiveness, a

staggering creative drive and the grace of epiphany. His esthetic, and no doubt his moral position as well, were made clear publicly thirty years ago in the typically unself-conscious remarks he delivered spontaneously at a Museum of Modern Art symposium in 1961: "Every minute everything is different everywhere. It is all flowing. . . . The duty or beauty of a painting is that there is no reason to do it nor any reason not to. It can be done as a direct act or contact with the moment and that is the moment you are awake and moving. It all passes and is never true literally as the present again leaving more work to be done."[63]

Footnotes

Unless otherwise noted, quotations are taken from conversations with the artists in connection with Sam Hunter's article, "Artist, Tramp, Robert Rauschenberg's Cultural Exchange: A Traveling International Art Project," *Elle* (April 1989), pp. 48–58.

1. Calvin Tomkins, *Off the Wall: Robert Rauschenberg and the Art World of Our Time*, (Penguin Books: New York, 1980), p. 205.
2. Jack Tworkov, cited in Calvin Tomkins's *The Bride and the Bachelors: Five Masters of the Avant Garde* (New York: Penguin Books, 1976), p. 193.
3. Sam Hunter, *Selections from the Ileana and Michael Sonnabend Collection*, exhibition catalogue (Princeton, New Jersey: The Art Museum, Princeton University, 1985), p. 21.
4. Brian O'Doherty, "Rauschenberg and the Vernacular Glance," *Art in America*, LXI (September 1973), p. 84.
5. *Masterworks in the Robert and Jane Meyerhoff Collection* (New York: Hudson Hills Press, 1995), p. 123.
6. Hunter, *Selections*, p. 23.
7. Dorothy Gees Seckler, "The Artist Speaks: Robert Rauschenberg," *Art in America*, LIV (May/June 1966), p. 74
8. Mary Lynn Kotz, *Rauschenberg/Art and Life* (New York: Harry N. Abrams, 1990), p. 265.
9. Ibid.
10. Kotz, op. cit. p. 49.
11. Ibid.
12. Kotz, op. cit. p. 52.
13. Kotz, op. cit. pp. 52–55.
14. "Robert Rauschenberg: An Audience of One," interview with John Gruen, *Art News*, 29 (February 1977), p. 48.
15. Maxime de la Falaise McKendry, "Robert Rauschenberg Talks to Maxime de la Falaise McKendry," *Interview*, 6 (May 1976), p. 34.
16. Calvin Tomkins, "Profiles: Robert Rauschenberg," *The New Yorker*, vol. 40 (Feb. 22, 1964), p. 101.
17. Calvin Tomkins, *The Bride and the Bachelors*, (Penguin Books: New York, 1962), p. 3.
18. Seckler, op. cit. p. 76.
19. Calvin Tomkins, *Off the Wall: Robert Rauschenberg and the Art World of Our Time*, (Penguin Books: New York, 1980), p. 89.
20. Kotz, op. cit. p. 56.
21. Tomkins, *The Bride and the Bachelors*, p. 196.
22. Robert Rauschenberg in conversation with the author, New York, 1998.
23. Lawrence Alloway, *Robert Rauschenberg*, exhibition catalogue, National Collection of Fine Arts (Smithsonian Institution: Washington, D.C., 1971), p. 25.
24. Kotz, op. cit. p. 60.
25. Tomkins, *The Bride and the Bachelors*, p. 197.
26. Alloway, p. 27.
27. Tomkins, *The Bride and the Bachelors*, p. 198.
28. Op. cit. p. 199.
29. Op. cit. pp. 199–200.
30. Tomkins, *Off the Wall*, pp. 55–56.
31. Andrew Forge, *Rauschenberg*, (New York: Harry N. Abrams, n.d.), p. 12.
32. Tomkins, *The Bride and the Bachelors*, p. 203.

33. Ibid.

34. Tomkins, *The Bride and the Bachelors*, pp. 203–204.

35. John Cage, "On Robert Rauschenberg, Artist, and His Work," *Metro 2*, May 1961, n.p.

36. *Salt Seller: The Writings of Marcel Duchamp (Marchand du Sel)*, ed. Michel Sanouille and Elmer Peterson, (New York, 1973), pp. 139–140.

37. Hunter, *Selections*, p. 24.

38. Kotz, op. cit. p. 82.

39. Ibid.

40. Ibid.

41. Kotz, op. cit. p. 89.

42. Ibid.

43. Robert Hughes, "The Most Living Artist," *Time* (Nov. 29, 1976), p. 60.

44. Tomkins, *Off the Wall*, p. 119.

45. Kotz, op. cit. p. 98.

46. Kotz, p. 99.

47. Ibid. p. 103

48. Tomkins, *Off the Wall*, p. 205.

49. Kotz, op. cit. p. 103.

50. Tomkins, *Off the Wall*, p. 209.

51. Hunter, "Artist, Tramp," p. 54.

52. Kotz, op. cit. p. 117.

53. Tomkins, *Off the Wall*, p. 11.

54. Walter Hopps, *Robert Rauschenberg, The Early 1950s*, Menil Collection exhibition catalogue (Houston: Houston Fine Arts Press, 1991).

55. Kotz, op. cit. p. 136.

56. Barbara Rose, *Rauschenberg* (New York: Vintage Books, 1987), p. 86.

57. Tomkins, *Off the Wall*, p. 292.

58. Ibid. p. 295.

59. Kotz, op. cit. p. 189.

60. Ibid. p. 206.

61. Hopps, p. 170.

62. Robert S. Mattison, *Breaking Boundaries: Robert Rauschenberg Prints from the Robert and Jane Meyerhoff Collection*, exhibition catalogue (New York: Whitney Museum of American Art, 1994), p. 3.

63. Roberta Bernstein, "Introduction," essay in catalogue for *Rauschenberg: The White and Black Paintings*, (quoting Rauschenberg from recording of a symposium held at the Museum of Modern Art, New York, in 1961, in conjunction with exhibit, *The Art of Assemblage*, (New York: Larry Gagosian Gallery, 1986), n.p.

Selected Bibliography

Dore Ashton, *Commentary: XXXIV Drawings for Dante's Inferno.* New York: Harry N. Abrams, 1965.

John Cage, "On Robert Rauschenberg, Artist and His Work," *Metro* (Milan) no. 2 (May 1961), pp. 36–51.

Roni Feinstein, "The Early Work of Robert Rauschenberg: The White Paintings, The Black Paintings, and the Elemental Sculptures," *Arts Magazine* (New York), 61, no. 1 (Sept. 1986), pp. 28–37.

Andrew Forge, *Rauschenberg.* New York: Harry N. Abrams, 1969.

Walter Hopps, *Robert Rauschenberg: The Early 1950s*, exhibition catalogue. Houston: The Menil Collection and Houston Fine Arts Press, 1991.

Walter Hopps and Susan Davidson, *Robert Rauschenberg, A Restrospective.* New York: The Guggenheim Museum with The Solomon R. Guggenheim Foundation, 1997.

Sam Hunter, "Artist, Tramp, Robert Rauschenberg's Cultural Exchange: A Traveling International Art Project," *Elle* (New York), Vol. IV, no. 8 (April 1989), pp. 48–56.

Jonathan Katz, "The Art of Code: Jasper Johns and Robert Rauschenberg," in Whitney Chadwick and Isabelle de Courtivron, (editors): *Significant Others, Creativity and Intimate Partnership*, pp. 189–207. London: Thames and Hudson, 1993.

Mary Lyn Kotz, *Rauschenberg: Art and Life.* New York: Harry N. Abrams, 1990.

Rosalind Krauss, "Rauschenberg and the Materialized Image," *Artforum* (New York), 13, no. 4 (Dec. 1974), pp. 36–43.

Robert S. Mattison, "Robert Rauschenberg," chapter in Mattison, *Masterworks in the Robert and Jane Meyerhoff Collection: Jasper Johns, Roy Lichtenstein, Robert Rauschenberg, Ellsworth Kelly, and Frank Stella*, pp. 97–128. New York: Hudson Hills Press, 1995.

"Robert Rauschenberg," chapter in Richard Kostelanetz, *The Theater of Mixed Means: An Introduction to Happenings, Kinetic Environments, and Other Mixed Means Performances*, pp. 78–99. New York: The Dial Press, 1968.

Barbara Rose, *Rauschenberg.* New York: Vintage Books, 1987. Published simultaneously in German. New York: Avedon Books; Cologne: Kiepenheuer & Witsch, 1987.

Charles F. Stuckey, "Reading Rauschenberg," *Art in America* (New York), 65, no. 2 (March–April 1977), pp. 74–84.

Calvin Tomkins, *Off the Wall: Robert Rauschenberg and the Art World of Our Time.* Garden City, N.Y.: Doubleday, 1980.

List of Illustrations

26. *Factum I*, 1957.
Combine painting: oil, ink, pencil, crayon, paper, fabric, newspaper, printed reproductions, and printed paper on canvas, 62×35¹/₂ in. (157.5×90.2 cm).
The Museum of Contemporary Art, Los Angeles. The Panza Collection.
Photo: Squidds and Nunns.

27. *Curfew*, 1958.
Combine painting: oil, paper, fabric, wood, engraving, printed reproductions, and printed paper on canvas and wood, with four Coca-Cola bottles, bottle cap, and unidentified debris, 56¹/₂×39¹/₂×2⁵/₈ in. (143.5×100.3×6.7 cm).
Collection of David Geffen, Los Angeles.

28. *Talisman*, 1958.
Combine painting: oil, paper, wood, glass, and metal, 42¹/₈×28 in. (107×71.1 cm).
Purchased with funds from the Coffin Fine Arts Trust; Nathan Emory Coffin Collection of the Des Moines Art Center, Iowa.
Photo: Michael Tropea, Chicago.

29. *Coca-Cola Plan*, 1958.
Combine painting: pencil on paper, oil on three Coca-Cola bottles, wood newel cap, and cast-metal wings on wood structure, 26³/₄×25¹/₄×4³/₄ in. (68×64.1×12.1 cm).
The Museum of Contemporary Art, Los Angeles. The Panza Collection.

30. *Monogram*, 1955–59.
Combine painting: oil, paper, fabric, printed paper, printed reproductions, metal, wood, rubber shoe heel, and tennis ball on canvas, with oil on Angora goat and rubber tire, on wood platform mounted on four casters, 42×63¹/₄×64¹/₂ in. (106.7×160.7×164 cm).
Moderna Museet, Stockholm.

31. *Gift for Apollo*, 1959.
Combine painting, 43³/₄×29¹/₂ in. (111.1×74.9 cm).
The Museum of Contemporary Art, Los Angeles, The Panza Collection.
Photo: Paula Goldman.

32. *Wager*, 1957–59.
Combine painting: oil, pencil, paper, fabric, newspaper, printed reproductions, photographs, wood and pencil body tracing on four canvases, 81×148×2¹/₄ in. (205.7×375.9×5.7 cm).
Kunstsammlung Nordrhein-Westfalen, Düsseldorf.
Photo: Walter Klein.

33. *Canyon*, 1959.
Combine painting: oil, pencil, paper, fabric, metal, cardboard box, printed paper, printed reproductions, photograph, wood, paint tube, and mirror on canvas, with oil on bald eagle, string, and pillow, 81³/₄×70×24 in. (207.6×179.1×61 cm).
The Sonnabend Collection, New York.

34. *Winter Pool*, 1959.
Combine painting: oil, paper, fabric, wood, metal, sandpaper, tape, printed paper, printed reproductions, handheld bellows, and found painting, on two canvases, with ladder, 90×59¹/₂×4 in. (228.6×151.1×10.2 cm) overall.
Collection of David Geffen, Los Angeles.

35. *Allegory*, 1960.
Combine painting: oil, paper, fabric, printed paper, wood, and umbrella on three canvases, and metal, sand, and glue on mirrored panel, 72¹/₄×114¹/₂×11³/₄ in. (183.5×290.8×29.8 cm) overall.
Museum Ludwig, Cologne. Ludwig Donation.
Photo: Rheinisches Bildarchiv, Cologne.

36. *Kickback*, 1959.
Combine painting, 76¹/₂×33¹/₄×2³/₄ in. (194.3×84.4×7 cm).
The Museum of Contemporary Art, Los Angeles. The Panza Collection.
Photo: Squidds and Nunns.

37. *Trophy I (for Merce Cunningham)*, 1959.
Combine painting, 66×41 in. (167.6×104.1 cm).
Kunsthaus, Zurich, Switzerland.

38. *Canto VI*, 1958.
(From "Thirty-Four Drawings for Dante's 'Inferno'"). Solvent transfer on paper, with gouache, pencil, watercolor, and wash, 14¹/₈×11¹/₂ in. (36.5×29.2 cm).
The Museum of Modern Art, New York; Anonymous Gift.

39. *Canto VIII*, 1959–60.
(From "Thirty-Four Drawings for Dante's 'Inferno'").
Solvent transfer on paper, with pencil, watercolor, gouache, and crayon, 14¹/₂×11¹/₂ in. (36.8×29.2 cm).
The Museum of Modern Art, New York; Anonymous Gift.

40. *Octave*, 1960.
Combine painting, 78×43 in. (198.1×109.4 cm).
Mr. and Mrs. Bagley Wright, Seattle, Washington.

41. *Trophy II (for Teeny and Marcel Duchamp)*, 1961.
Combine painting: oil, charcoal, paper, fabric, printed paper, printed reproductions, sheet metal spring on seven canvases, with chain, spoon, and water-filled plastic drinking glass on wood, 90×103×5 in. (228.6×274.3×12.7 cm) overall.
Walker Art Center, Minneapolis. Gift of the T. B. Walker Foundation, 1970.

42. *Reservoir*, 1961.
Combine painting, 85¹/₂×62¹/₂×14³/₄ in. (217.2×158.8×37.5 cm).
National Museum of American Art, Washington, D.C.

43. *Second Time Painting*, 1961.
Oil and assemblage on canvas, 66×42×4 in. (167.6×106.7×10.2 cm).
Rose Art Museum, Brandeis University, Waltham, MA. Gevirtz-Mnuchin Purchase Fund, 1962.

44. *First Landing Jump*, 1961.
Combine painting: cloth, metal, leather, electric fixture, cable, and oil paint on composition board; with automobile tire and wooden plank, 89¹/₃×72×6⁵/₈ in. (226.4×182.8×16.8 cm).
The Museum of Modern Art, New York. Gift of Philip Johnson.

45. *Trophy IV (for John Cage)*, 1961.
Combine: metal, fabric, leather boot, wood, and tire tread on wood, with chain and flashlight, 33×82×21 in. (83.8×208.3×53.3 cm).
San Francisco Museum of Modern Art, California.

46. *Barge*, 1962–63.
Oil and silkscreened ink on canvas, 79⁷/₈×386 in. (203×980.44 cm).
Guggenheim Bilbao Museoa and The Solomon R. Guggenheim Foundation, New York.

47. *Ace*, 1962.
Combine painting, 108×240 in. (274.3×609.6 cm).
Albright-Knox Art Gallery, Buffalo, New York.
Gift of Seymour H. Knox, 1963.

48. *Dylaby*, 1962.
Combine painting, 109¹/₂×87×15 in. (278.2×221×38.6 cm).
The Sonnabend Collection, New York.

49. *Kite*, 1963.
Oil and silkscreened ink on canvas, 84×60 in. (213.4×152.4 cm).
The Sonnabend Collection, New York.

50. *Estate*, 1963.
Oil and silkscreened ink on canvas, 95³/₄×69³/₄ in. (243.2×177.8 cm).
Philadelphia Museum of Art, Pennsylvania. Gift of the Friends of the Philadelphia Museum of Art.

51. *Scanning*, 1963.
Oil and silkscreened ink on canvas, 55³/₄×73 in. (141.6×185.4 cm).
San Francisco Museum of Modern Art, California.

52. *Tadpole*, 1963.
Oil and silkscreened ink on canvas with inner tube and other objects, 48×30¹/₄ in. (121.9×76.8 cm).
Barbara and Richard S. Lane, New York.
Photo: Robert E. Mates.

53. *Persimmon*, 1964.
Oil and silkscreened ink on canvas, 66×50 in. (167.6×127 cm).
Jean-Christophe Castelli, New York.

54. *Retroactive I*, 1964.
Oil and silkscreened ink on canvas, 84×60 in. (213.4×152.4 cm).
Wadsworth Atheneum, Hartford, Connecticut.
Gift of Susan Morse Hilles.

55. *Quote*, 1964.
Oil and silkscreened ink on canvas, 92×72 in. (239×183 cm).
Kunstsammlung Nordrhein-Westfalen, Düsseldorf, Germany.
Photo: Walter Klein.

56. *Oracle*, 1962–65.
Five-part found-metal assemblage with five concealed radios:

ventilation duct; automobile door on typewriter table, with crushed metal; ventilation duct in washtub and water, with wire basket; constructed staircase control unit housing batteries and electronic components; and wood window frame with ventilation duct. Installation dimensions variable. Engineers: Billy Klüver, Harold Hodges, Per Biorn, Toby Fitch, and Robert K. Moore. Musée National d'Art Moderne, Centre Georges Pompidou, Paris, Gift of Sao and Pierre Schlumberger.

57. *Mainspring*, 1962–65. Solvent transfer on paper, with pencil, watercolor, gouache, cardboard, and tape, 32×62½ in. (81.3×158.8 cm). Private collection.

58. *N. Y. Bird Calls for Oyvind Fahlstrom*, 1965. Silkscreened ink on cut-and-torn papers stapled to canvas and covered with Plexiglas, with hockey stick, hose, metal garbage-can lid, antenna, metal, spring, film canister, and chains, 93×82×11 in. (236.2×208.3×27.9 cm); installation variable. Private collection, courtesy of Edward Tyler Nahem, New York.

59. *Revolver*, 1967. Silkscreened ink on five rotating Plexiglas discs in metal base, with electric motors and control box, 78×77×24½ in. (198.1×195.6×62.2 cm). Collection of the artist.

60. *Booster*, 1967. Color lithograph and silkscreen on paper, 72×25½ in. (182.9×90.2 cm). From an edition of thirty-eight published by Gemini G.E.L., Los Angeles. Collection of the artist. Photo: Sally Ritts.

61. *Soundings*, 1968. Mirrored Plexiglas and silkscreened ink on Plexiglas, with concealed electric lights and electronic components, 94×432×54 in. (238.8×1,097.3×137.2 cm). Engineers: Billy Klüver, L. J. Robinson, Fred Waldhauer, Cecil Coker, Per Biorn, and Ralph Flynn. Museum Ludwig, Cologne. Ludwig Donation. Photo: Rheinisches Bildarchiv, Cologne.

62. *Signs*, 1970. Silkscreened print (edition of 250, Castelli Graphics), 43×34 in. (109.2×86.3 cm). Collection of the artist. Photo: Dorothy Zeidman.

63. *Brick*, 1970. Cut-and-pasted newspaper on paper, with watercolor, gesso, and pencil, 40×27½ in. (101.6×69.9 cm). The Sonnabend Collection, New York.

64. *Mud-Muse*, 1968–71. Bentonite mixed with water in aluminum-and-glass vat, with sound-activated compressed-air system and control console, 48×108×144 in. (121.9×274.3×365.8 cm). Engineers: Frank LaHaye, Lewis Ellmore, George Carr, Jim Wilkinson, and Carl Adams. Sound artist: Petrie Mason Robie. Moderna Museet, Stockholm. Gift of the New York Collection, 1973.

65. *Nabisco Shredded Wheat (Cardboard)*, 1971. Cardboard on plywood, 70×95×11 in. (177.8×241.3×28 cm). Collection of the artist.

66. *Franciscan II (Venetian)*, 1972. Fabric, resin-coated cardboard, tape, string, and stone, 87×116×47½ in. (221×294.6×120.7 cm); installation variable. The Museum of Modern Art, New York. The Kay Sage Tanguy Fund, 1977.

67. *Sor Aqua (Venetian)*, 1973. Wood, metal, rope, glass jug, and water-filled bathtub, 98×120×41 in. (248.9×304.8×104.1 cm). Collection Teresa Bjornson, Los Angeles.

68. *Untitled (Venetian)*, 1973. Cardboard and paper on plywood support with fabric, 64×85½×12½ in. (162.6×217.2×31.8 cm). Collection of the artist.

69. *Untitled (Venetian)*, 1973. Tire and wood pole, 109½×26½×19 in. (278.1×67.3×48.3 cm). Collection of the artist.

70. *Sybil (Hoarfrost)*, 1974. Solvent transfer on silk and chiffon, with paper bags and rope. 80×74¾ in. (203.2×189.9 cm). Collection of the artist.

71. *Sulphur Bank (Hoarfrost)*, 1974. Solvent transfer on satin, chiffon, and cardboard, 65×35 in. (165.1×88.9 cm). Collection of the artist.

72. *Pilot (Jammer)*, 1976. Sewn silk, rattan pole, and string, 81×85×39 in. (205.7×215.9×99.1 cm). Collection of the artist.

73. *Rodeo Palace (Spread)*, 1975–76. Solvent transfer, pencil, and ink on fabric and cardboard, with wood doors, fabric, metal, rope, and pillow, mounted on foam core and redwood supports, 144×192×5½ in. (depth variable) (365.8×487.6×14 cm). Collection Norman and Lyn Lear, Los Angeles.

74. *Coin (Jammer)*, 1976. Sewn fabric with objects, 89×43×19 in. (226.1×109.2×48.3 cm). Collection of the artist.

75. *Corinthian Covet (Spread)*, 1980. Solvent transfer and collage on plywood panels with objects, 84×185×19 in. (213.3×469.9×48.3 cm). Collection Robert and Jane Meyerhoff, Phœnix, Md.

76. *Tattoo (Spread)*, 1980. Solvent transfer, acrylic, paper, and fabric, with wind socks and metal fixures, on wood, 73¾×96⅝×19 in. (187.3×245.4×48.3 cm). Collection of the artist.

77. *Pegasus' First Visit to America in the Shade of the Flatiron Building (Kabal American Zephyr)*, 1982. Solvent transfer, acrylic, and collage on plywood and aluminum with objects, 96½×133½×22½ in. (245.1×339.1×57.2 cm). Collection of the artist.

78. *Untitled (Kabal American Zephyr)*, 1983. Assembled construction, 73×20×24 in. (185.4×50.8×61 cm). Collection of the artist.

79. *Fish Park (ROCI Japan)*, 1984. Acrylic and fabric collage on canvas, 78½×220¼ in. (199.4×559.4 cm). Hiroshima City Museum of Contemporary Art, Japan.

80. *Guarded Mirror Rivers (ROCI Venezuela)*, 1985. Acrylic and fabric on plywood, 49½×98⅝ in. (125.7×250.2 cm). Collection of the artist.

81. *Shade (Salvage)*, 1984. Acrylic on canvas, 81¼×97¾ in. (216.4×248.3 cm). Collection of the artist.

82. *Dancing Cliche (Shiner)*, 1986. Acrylic and objects on stainless steel sheet with aluminum frame, 48¾×60¾ in. (123.8×154.3 cm). Collection of the artist. Photo: Dorothy Zeidman.

83. *Rudder Glut*, 1986. Assembled construction, 26×37×11 in. (66×94×27.9 cm). Collection of the artist.

84. *Carnival Glut*, 1986. Construction, 50×73×43 in. (127×185.5×109 cm). Collection of the artist.

85. *Read Lead Glut*, 1986. Riveted metal parts, 76×96¾×39½ in. (193×245.7×100.3 cm). Collection of the artist. Photo: Dorothy Zeidman.

86. *Flaghole Glut*, 1987. Construction of found aluminum and metal objects, 32×100×59 in. (81×254×150.cm). Collection of the artist. Photo: Dorothy Zeidman.

87. *Ballast (Shiner)*, 1987. Acrylic and objects on stainless steel, 48¾×120⅞×20 in. (123.8×307×50.8 cm). Collection of the artist.

88. *Primary Mobiloid Glut*, 1988. Assembled construction, 44×67×27 in. (variable) (112×170×69 cm). Collection of the artist.

89. *Snow Gate Winter Glut*, 1987.
Assembled metal parts,
24×130¹/₂×16 in.
(61×331.5×40.6 cm).
Collection of the artist.
Photo: Dorothy Zeidman.

90. *Greek Yearn (Urban Bourbon)*, 1988.
Enamel and acrylic on anodized
aluminum, 84³/₄×72³/₄ in.
(215×185 cm).
Collection of the artist.

91. *Favor-Rites (Urban Bourbon)*, 1988.
Acrylic on mirrored and enameled
aluminum, 120³/₄×96³/₄ in.
(307×246 cm).
Collection of the artist.

92. *Sleeping Sweeper (Urban Bourbon)*,
1988.
Acrylic and enamel on mirrored
anodized aluminum,
96³/₄×120³/₄ in.
(246×307 cm).
Collection Paine Webber Group
Inc., New York.

93. *Novel Quote (Urban Bourbon)*, 1988.
Acrylic on enameled aluminum,
120³/₄×96³/₄ in.
(306.7×246 cm).
Collection of the artist.

94. *Courtyard (Urban Bourbon)*, 1989.
Acrylic and enamel on enameled
aluminum, 121×144³/₄ in.
(307.4×367.7 cm).
Collection of the artist.

95. *Grand Slam (Galvanic Suite)*, 1990.
Acrylic and enamel on mirrored
aluminum and galvanized steel,
4 panels, 121¹/₄×193¹/₂ in.
(308×491.5 cm).
Collection of the artist.

96. *A Doodle (Borealis)*, 1990.
Acrylic and tarnishes on brass,
72³/₄×96³/₄ in. (184.8×245.8 cm).
Private collection, Switzerland.

97. *Orrery (Borealis)*, 1990.
Acrylic and tarnishes on brass with
brass objects, 97×181×23 in.
(246×460×58.5 cm).
Kunstsammlung Nordrhein-
Westfalen, Düsseldorf.

98. *Cradle Tilt (Borealis)*, 1991.
Acrylic and tarnishes on brass,
91×36⁷/₈ in. (231.1×93.7 cm).
Collection of the artist.
Photo: Ken Cohen.

99. *Rudy's Time (Night Shades)*, 1991.
Tarnishes on brushed aluminum,
85×97 in. (216×246.5 cm).
Collection of Ana and Michael
Goldberg.

100. *Washington's Golden Egg / ROCI USA
(Wax Fire Works)*, 1990.
Acrylic, enamel, and fire wax on
mirrored aluminum and stainless
steel, 96³/₄×189¹/₂×13¹/₂ in.
(245.8×481.3×34.3 cm).
Made in collaboration with Saff
Tech Arts, Oxford, Maryland.

Collection of the artist.
Photo: George Holzer.

101. *Tabernacle Fuss (Urban Bourbon)*,
1992.
Acrylic on enameled aluminum,
121×241 in. (307.3×612.1 cm).
Collection of the artist.

102. *Intersection (Night Shade)*, 1991.
Acrylic and tarnishes on brushed
aluminum, 85×49 in.
(215.9×124.5 cm).
Collection Peter C. A. Holm,
Courtesy of Galleri Faurschou,
Copenhagen.

103. *Eco-Echo IV*, 1992–93.
Acrylic and silkscreened acrylic on
aluminum and Lexan, with sonar-
activated motor, bicycle wheel and
steel base.
88¹/₂×73¹/₂×28¹/₂ in.
(224.8×186.7×72.4 cm).
Made in collaboration with Saff
Tech Arts, Oxford, Maryland,
Collection of the artist.

104. *A Quake in Paradise (Labyrinth)*,
1994–95.
Acrylic and graphite on 29 panels
of bonded aluminum, anodized
mirrored aluminum, and
polycarbonate (Lexan) with
aluminum framing.
Variable dimensions and panel
groupings.
"Diver" images courtesy
Aaron Siskind Foundation.
Collection of the artist.